Praise for *Candy and Me*

"*Candy and Me* is delightful, a hilarious, counterintuitive romp through stacks of Necco Wafers, Smarties, Snickers, and Jelly Bellies . . . readers will agree that a life without sugar and love is a sour life indeed."

—*USA Today*

"Proust had his madeleines—Hilary Liftin has Junior Mints. And candy corn, Starburst, and Skittles, all of which unleash a flood of memories about things past in *Candy and Me*. . . . *Candy* is dandy . . . it is a delicious read: often bittersweet and occasionally as gritty as a Root Beer Barrel."

—*New York Post*

"Fresh and lively and oh-so-tongue in cheek . . . *Candy and Me* must be read all at once, in one sitting, page after page consumed in a sated haze of sweet delirium."

—*The Globe and Mail*

"I devoured it in a matter of hours, vicariously tasting the Bottle Caps, Circus Peanuts, and Junior Mints with the turn of each page."

—*Chicago Daily Herald*

"When I discovered Hilary Liftin's memoir . . . my heart leapt!"

—*Elle Girl*

"Need a yummy book for the beach? Read *Candy and Me*."

—*Seventeen*

"A touching and interesting story."

—*Booklist*

"Engaging, humorous, and well-paced writing."

—Library Journal

"Liftin's writing is fluid and engaging, inviting consumption at one sitting—and, for some, instigating a mad rush to the closest candy counter."

—Publishers Weekly

"Funny, warm, and compulsively readable."

—curledup.com

"This book is funny and captivating; a delight. And I feel much better about my little problem with popcorn."

—Haven Kimmel, author of the bestselling
A Girl Named Zippy and Something Rising (Light and Swift)

"Elegantly written, poignant, funny, and oh-so-sweet, Hilary Liftin's memoir of love and longing for candy, among a cornucopia of other things, is sheer satisfaction."

—Jenny McPhee, author of The Center of Things

"Boring people measure life by money or prestige, but Hilary Liftin uses candy as her standard. She eats it, shares it, hoards it, buys it, denies it, and glorifies it; and as she reveals her fantastic love affair with it, we read her memoir like children filling up booty bags on Halloween night. What bounty! What surprise and joy this book contains!"

—Jane and Michael Stern, authors of Roadfood
and Eat Your Way Across the USA

"*Candy and Me* is pure comedy, and yet this lovely little book ultimately asks a quite serious question: Is the one road to human happiness on earth made of sugar?"

—David Shields, author of Enough About You

Also by Hilary Liftin

*Dear Exile: The True Story of Two Friends
Separated (for a Year) by an Ocean*
(with Kate Montgomery)

Hilary Liftin

FREE PRESS

NEW YORK LONDON TORONTO SYDNEY

OOOOOOOOO

CANDY
AND ME

*A Girl's Tale
of Life, Love, and Sugar*

OOOOOOOOO

FREE PRESS
A Division of Simon & Schuster, Inc.
1230 Avenue of the Americas
New York, NY 10020

First Free Press trade paperback edition 2004

FREE PRESS and colophon are trademarks of Simon & Schuster, Inc.

For information about special discounts for bulk purchases,
please contact Simon & Schuster Special Sales:
1-800-456-6798 or business@simonandschuster.com
For more about this book, visit www.hilaryliftin.com

Book design by Ellen R. Sasahara

Manufactured in the United States of America

10 9 8 7 6 5 4 3 2 1

The Library of Congress has catalogued the hardcover edition as follows:
Liftin, Hilary.
Candy and me : a love story / Hilary Liftin.
p. cm.
1. Liftin, Hilary—Biography. 2. Candy. I. Title.
TX783..L53 2003
641.3—dc21 2002192871

ISBN 0-7432-4573-3
ISBN 0-7432-5441-4 (Pbk)

> **WARNING:**
>
> The experiences described in this book are not recommended by dentists to their patients who chew gum. Please do not try this at home.

For Chris, my everything

Call the roller of big cigars,
The muscular one, and bid him whip
In kitchen cups concupiscent curds.
Let the wenches dawdle in such dress
As they are used to wear, and let the boys
Bring flowers in last month's newspapers.
Let be be finale of seem.
The only emperor is the emperor of ice-cream.

From "The Emperor of Ice-Cream" by Wallace Stevens

Contents

OOOOOOOOO

Contents

Contents

CANDY
AND ME

Introduction
Bubble Burgers

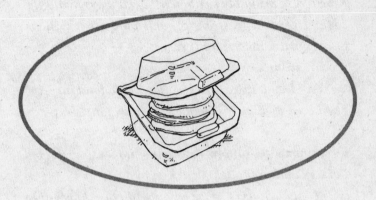

It all began when my brother entered the fourth grade. His new school let out too late for our carpool to the suburbs, so he had to take the city bus. One day he came home carrying a Bubble Burger. The Bubble Burger was a pioneer in the less-than-inspiring category of bubble gum shaped like real-world objects. I was still in the third grade, and I looked at Eric's Bubble Burger with wonder.

"Where did you get it?"

"In a little store called Alban Towers," he said nonchalantly, as if we'd had the freedom to buy whatever candy we wanted every day of our lives.

"How much did it cost?"

"A quarter," he said with his mouth stuffed.

"Will you get me one?"

"Sure."

Introduction

○

The next day Eric brought me my first Bubble Burger. I chewed it, probably swallowed it (I always found the concept of gum frustrating), and plopped six allowance quarters down on his rug.

"You want six?"

"Yes," I said. Eric shrugged. It wasn't a total surprise. I had been stealing his Halloween candy for years.

I continued to supply Eric with money for Bubble Burgers until a thought occurred to me.

"At Alban Towers," I asked him, "do they have other kinds of candy?"

He rolled his eyes. "Of course they do."

"Like what?" I asked.

"Everything," he said. I had no idea what everything was. I racked my brain to remember the kinds of candy I had seen at the grocery store. Finally, I dumped eight quarters on the rug.

"Just get me anything."

Candy is almost pure sugar. It is empty of nutritional value. It is an extravagance. It dissolves in water. It melts in your mouth, not in your hands. It's the icing on the cake. Candy is so impossibly sweet and good that eating it should be the simplest thing in the world. So how can there be anything of substance to say about it?

And yet, candy's meaning has more subtlety than its taste. It affords a fleeting spike of pleasure, sometimes guilty or elusive or bittersweet, like an impossible love affair. I've

thought myself addicted and tried to quit. I've embraced my candy-lover identity and championed the cause. I've eaten it for joy, to relax, to celebrate, and out of boredom. I've eaten it through thick and thin and not-fat-but-not-thin. I love it, I hate it, and it's always been there, through childhood, adolescence, and into my adult life. Candy, and its erratic, delightful, fattening, odd rainbow presence, is an obsession that has fueled and flavored my life. When I walk into a candy store, the shelf of assorted treats evokes a series of individually wrapped memories, ready for the tasting.

As I look back on my candy life, what has been most thrilling was to discover I haven't been alone. Sure, there are people I've encountered who shrug off candy and go back to eating their pretzels. Others think that I'm a bit sick. But far more often, the mention of candy triggers long, enthusiastic exchanges about top candies, addictions and repulsions, flavors and habits. On occasion, with more people than I could have imagined, conversation turns to the emotional resonance that grows from a lifetime of candy eating.

Candy is important, and it's about time it got its just "desserts."

OOOOOOOOO

Part One

SWEET TOOTH

OOOOOOOOO

Sugar

Before there was candy, there was sugar. My brother and I started staying without a babysitter when I was seven and he was eight. We had a barter/bribe relationship: for every serving of sugar I ate, Eric could stay up an extra hour. We pledged not to tell on each other to our parents. As soon as they walked out the door, I would pour several tablespoons of confectioner's powdered sugar into a Dixie cup. I eventually figured out that if I ran a few drops of water or milk into the cup and mixed it up, semi-soft pellets formed. The texture of these pellets was dreamy. Sometimes I would add a drop of vanilla extract and a bit of butter. Then, in front of the (also forbidden) TV, I would dip a spoon into the sugar and feed myself.

Our suburban Maryland family room had a pale brick fireplace, wall-to-wall shag carpeting, and psychedelic pillows.

Eric reclined on the couch and I sat on the velour lounge chair. We watched the Osmonds, *Rhoda*, *The Wonderful World of Disney*. On any night that I started eating sugar, which was every night my parents didn't hire a babysitter, I would have refill after refill. I ate it furtively, afraid that my parents would walk in unexpectedly. I loved the way the sugar became sweeter just before it dissolved on my tongue. Watching illicit TV while eating sugar became a habit. The combined relaxation, indulgence, and jolt of forbidden sweetness that I found in my candy-leisure moments were forever established as sensations to pursue. If Charles Schulz had created a comic-strip version of me at seven, I would have been surrounded by a cloud, but unlike Pigpen's dirty cumulus, my cloud would have been a pure, refined puff of powdered sugar.

At some point Eric stopped calculating the late night hours he was accumulating and threw up his hands.

"I can't believe you're eating all that sugar," he said. "You'll be sick." But I didn't feel sick. Rather, I was astounded that Eric had no apparent interest in the bounty I had discovered. I don't remember ever getting caught or in trouble, although I know my mother must have had some idea that this was going on. I also never wondered why there was always powdered sugar in the house—even though my mother never baked. It was only later that I discovered that she herself had a secret habit. But eventually she decided not to stock sugar in the pantry anymore, and I had to move on.

Trix

In 1954, Trix breakfast cereal was introduced by General Mills. The new cereal, a huge hit with kids, was 46.6 percent sugar.

—UselessKnowledge.com

I loved Trix.

Candy Corn

The earliest candy corn memory I have is of my mother carefully spreading several bags of the product across the kitchen table. She was teaching herself to be a painter and was arranging a candy corn still life. Eric and I were instructed not to touch or eat a single kernel. Our mother acted as if this were a perfectly reasonable request, as if she were painting a still life of spinach, or pork lard. One comes into the kitchen, one is young, one is hungry, and one sees a table covered with one's favorite candy. She couldn't have painted a fruit basket? It was a cruel world, mismanaged by adults who knew their own power too well.

Candy corn may seem timeless, but it was born at the Wunderle Candy company in the 1880s. That whole school of candy—mellocremes—was already in full swing, in various agriculturally inspired shapes and sizes. Then in 1898

Goelitz Confectionery Company took candy corn into the big leagues, associating the confection with Halloween. It was, needless to say, a big hit. And why shouldn't it have been? Candy corn was made for stardom. Those shiny, waxy yellow ends demand to be clutched by the handful and eaten, top, middle, bottom, top, middle, bottom, in a compulsive rhythm until they are gone. Chocolate gets all the fanzines, but it is the clay of candy. Matte, endlessly shapeable, chocolate is all about taste. Candy corn gets by on looks alone. Odes should be written to its waxy gleam, its whimsical design, its autumnal shades.

I fell for candy corn hard. It was the first candy for which I had a specific desire rather than a generic sugarlust. I loved how it returned, Halloween after Halloween. We trick-or-treated on the overly lit cul-de-sacs of suburban Maryland, compromising our store-bought costumes by donning coats. We ran from house to house, suffocating plastic masks pulled up onto the tops of our heads. One popular house distributed full-size Three Musketeers bars. Candy corn came in slender, oblong boxes or little plastic bags cherishing only four or five kernels. At the end of the night our brown paper bags were awkwardly heavy. It was never enough. I usually ate all of my candy by the next evening, and then started in on my brother's. When I got tired of the sugary candies in our bags, I switched to chocolate, then back again.

Candy corn marked the passage of time. Every year autumn brought a Pavlovian desire for it. I counted the years by

Halloweens rather than birthdays, and the taste of candy corn meant a new costume, a new year of school. All summer I looked forward to October 31. I thought that it was my favorite day of the year. But, as is the way with candy, I was never satisfied. I was always waiting for more to happen, or for something to change, although I had no idea what. The day after Halloween I was inevitably sad and disappointed, and would begin planning how the next time my costume would be better, how I would stay out later and collect enough candy to last longer. That cyclic disappointment clawed at me. Every passing year, though I thought candy corn delighted me, it was the constant, stealthy reminder that satisfaction was out of reach. It would be a long while before I would see how alienated and uncomfortable I was in the world, and how young I was when I started hoping that sugar would sweeten the deal.

Cocoa

When a child is a misfit, it isn't always easy to pinpoint why. I may have had two or three friends, but I had the awkwardness of an adolescent four years too early. Making friends and going to school were, for me, an exercise in pretending to be normal. I was overwhelmed with self-consciousness. Not only was I prematurely uncool, but there was no end in sight. I had no idea what was wrong with me, but I was certain that I was and would always be a loser. This inevitable future was not obvious to everyone else, but I knew that with one false move I would be revealed.

In the fourth grade at the National Cathedral School for Girls our uniforms were see-through striped dresses, which became a problem for some of the girls almost immediately. We wore the juvenile outfits with knee socks, cardigan

sweaters, and Sperry Topsiders. Unable to base itself on the traditional criteria of clothing and fashion, popularity thus became contingent on the puffy sticker trading market. For some reason my parents couldn't manage to let me purchase the right style of stickers in the necessary quantities—it was just the beginning of my social undoing.

The school served a hot lunch in the cafeteria every day, before which we had to stand and sing a hymn. Every day I supplemented my meal with chocolate milk, dessert, and hot chocolate. We were allowed one serving of each. But one day after school, my best friend Lucy and I ventured back into the closed cafeteria. It was miraculously unlocked. There we discovered the packets of Ready-Mix cocoa in their plastic bowl, left out under a paper doily for the next day. We each grabbed three and hurried out.

By then my family had moved from Bethesda, Maryland, into Washington, D.C. Our new house was close to my school, and Lucy lived next door. As we walked home, we dipped our index fingers into packets of the cocoa, scooping sloping peaks of it into our mouths. Our fingers turned brown and soggy, and it grew difficult to summon enough saliva to dissolve the cocoa crystals, but we were determined. We started with three packs each, but soon I was up to seven a day. Even I was amazed at how my capacity skyrocketed. I would eat a few as I walked home, and then would go directly to my room, lie on the carpet, and eat the rest as I read my textbooks. Before long my cocoa thievery gained me a bit of a reputation. I had been seen eating it in class, and let a few others in on my strategy. But no one

embraced it quite as I did. For the other girls it was a lark, but for me it was no novelty. It was a covert way of life.

Our school was on the Close of the Washington National Cathedral, which was still under construction then. Carved stones that would complete the western door were laid out like grave markers near the stonecutter's cottage. The periodically vanishing stones made it seem as if life were moving backward, a creepy resurrection. Lucy and I walked home through this reverse graveyard daily. From our religion class and the mandatory weekly services at the cathedral, we knew the basic map of its cruciform well. We also knew that there were places we hadn't fully explored: a sub-crypt, and a bell tower, and we were certain that somewhere there were damp, dark, forgotten chapels where monks and ascetics were starving and chanting. Made bold by the dry cocoa, we frequently wandered into the cathedral. Looking devout as we slipped down into the lower floors, we peeked behind tapestries and found dark stairways that curved toward locked wooden doors.

We were at an age when believing in Santa and the tooth fairy was long over, but I was still open to spirituality. I clung to a porous hope that some magic or god might be found in daily life. Bound into this was the unconscious idea that if I could believe in some greater power, then life wouldn't suck so hard. Salvation had a schoolgirl's definition: I could be self-confident, popular, even a tall, skinny lacrosse player, if only I had faith. As I walked to school, I counted my paces in multiples of seven, and if I arrived at

the curb on seven, a dream would come true. Cars passed, leaves fell, I climbed stairs, I counted the letters in words and wishes looking for signs that some force was listening and would heed my pledges of faith-if-only.

One morning on the way to school, Lucy and I found a Bible on the sidewalk. We figured it was a sign, and launched a full week of piety. We would slip into a basement chapel, find the Bible where we had stowed it, and flip through it, feeling Chosen. Our passion was fevered, but directionless. Would it settle on God or academia, boys or poetry (or horses)? Being religious was a possible future identity that we tried on for size before discarding it for the next. That is, as soon as the Bible disappeared from its hiding place in the crypt, we moved on.

I consumed the illicit cocoa with the same fervor with which I wanted to believe that life wasn't accidental. As we added rituals and volume to our consumption, it seemed that my life might take shape. That is, the sugar elevated my mood and gave me purpose, and if I kept eating it in increasing quantities, then maybe I would be magically transformed into the embodiment of that sugar high. Four packs, five packs, six packs a day. There was no limit to the happiness and fulfillment I might find.

Unlike our fleeting Bible studies, cocoa held our attention for most of that year. We hid out in small chapels, downing dry gulps of the stuff. My secret longing for a sign of hope, for confidence and faith, accompanied each hastened swallow. I may not have found the social grace I craved, but at the height of the obsession cocoa provided an even greater

release. When we heard footsteps approaching our hideout, we would burst into laughter, and billows of cocoa would escape out into the air. The sight of each other's brown-laced mouths and tongues put us over the edge, and there we would be found by one clergyman or another, consoled, enlightened, rapt in ecstasy, rolling on the stone floor of the crypt in silent brown laughter.

Ice Cream

Ice-cream consumption was a problem in our household. Whenever my mother bought a carton of ice cream, I would eat most of it right away. This wasn't fair to the other members of the family. My mother didn't want to increase the quantity of ice cream that I ate, but she wanted everyone to be able to have some. She decided that she would buy three half-gallon cartons at a time. One for me, one for my brother, and one for the parents. She would make this purchase once every three weeks, so I could make my half-gallon last for three weeks, or I could eat it all right away, but that was my ration.

I always got mint chip, and, never one to waste time, I ate my half-gallon in the first two days. My brother made his last, eating a scoop or two every three days. This drove me mad. One afternoon, long after my supply had dried up, I

opened his carton. He hadn't eaten any yet. I figured that if I just ate around the edge, he wouldn't notice. I traced a light canal around the perimeter of the carton with my spoon. Rocky Road. After three or four laps around the carton I determined that my invasion was still undetectable. I sealed it back up and scurried upstairs.

The next afternoon, I returned to the scene of the crime. Again, I furrowed delicately around the edge of the carton. The ice cream still reached the top; it just had a neat moat around it that was certainly no cause for alarm. But that night my brother opened his ice cream.

"Mom, doesn't this ice cream look weird?" She agreed that there was something wrong with it. They stood over the carton, trying to figure out what might have happened.

"Maybe it melted in the store?" Eric suggested.

"Maybe," she said. "I'll take it back. I don't think you should eat it. Something is wrong with it."

Taking it back to the store? I panicked. If they took it back to the store, I would surely be discovered and possibly arrested. When I confessed to my crime, I was cut out of the next few rounds of ice-cream purchasing.

Some months later I came up with a new approach. Again, my mint chip was long gone, leaving me to gaze long-ingly at my brother's half-gallon of Oreo, which sat nearly full in the freezer. It was in a rectangular box, which opened at the small top instead of the wide side. My brother had taken a few nibbles, but the rest was intact. I spooned out a bit from the top, but knew I couldn't go much further with-out detection. Then I had an idea. I opened the bottom of the

box and began a rear-entry sneak attack. It was subtle at first, but as the week passed, I grew bolder until I had eaten about a third of the carton, from the bottom.

Then my poor brother, in the ordinary course of scooping his ice cream, broke through to the gaping vortex that should have been the remainder of his supply. This time there were no mysteries. My gall astounded my mother. My brother was genuinely curious.

"Did you truly believe that I wouldn't figure it out?"

I kind of did. Actually, I had hoped that the ice cream might slide down to fill the void as he served himself, the way it creeps further into an ice-cream cone as you eat it. But that was the end of ice cream in our household. From then on, when we wanted ice cream, we went out to the parlor. One scoop each, no thievery, no plotting, no fun.

The ice cream in my adult life comes in pint-size cartons and is oozing with various forms of caramel, fudge, and peanut butter. (Whether it is labeled low-fat or frozen yogurt—I have spent whole years limiting myself to one or the other— makes no difference in my weight.) At first the pint seemed like a curse—it had to be polished off regardless of whether there was help from a lover's spoon. But remembering the struggles I had had with the half-gallons of my youth, I became grateful for the pint. The size is right. To my delight, finishing a pint by myself is a bit too difficult. I can do it on occasion, but it takes hunger, time, and determination. Leftover ice cream always makes me proud. But the pint is also just enough to share without sparking competitive consump-

tion. It feels like one-and-a-half servings each. The only challenge is the rush for whatever buried candy nuggets must be unearthed. This is a real test of character: What better way to display true love than to mine a luscious peanut butter cup, only to offer it to your mate? Believe me, it took me a long time to get there.

Flake

My father kept coffee nips in his den, but I couldn't stand the taste of coffee. The only other time I saw him eat candy was when he was skiing. Then he would keep a gourmet chocolate bar in his jacket. On the ski lift, he would eat a single square at a time and offer us as much. He had no idea of how it tortured me. My father worked long hours and then came home to work more. My mother painted in her studio, reared us, and learned to cook elaborate dinners, which wilted on the stove while my father ran late at work. He took frequent business trips to England, or to even farther countries with stopovers at Heathrow Airport. Whenever he went through Heathrow, he brought us Cadbury Flakes. These were stubby chocolate sticks made of compressed flakes of chocolate, invented by a machine operator who watched the excess chocolate gather in ripples at the edge of a chocolate machine. I imagine him fingering

those tasty leftovers, dreaming his way out of the chocolate factory. The Flake TV advertisements, which started in the late 1950s, always showed "The Flake Girl" in some exotic locale. My father fed that escapist theme, returning home with Flakes from distant lands where they were common.

My Flake would crumble into its yellow wrapper as I ate it, and when it was gone I would lick up every last crumb. We didn't see my father much, but we loved those Flakes.

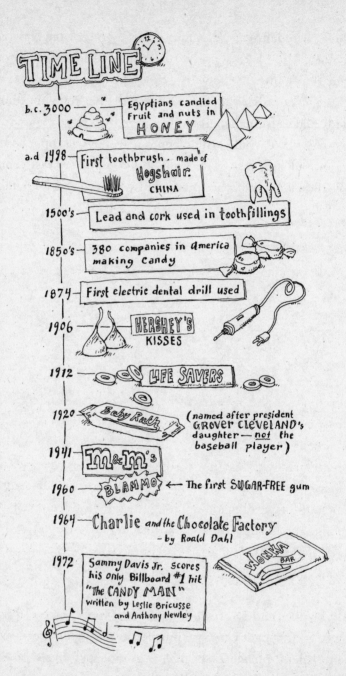

TIME LINE

b.c. 3000 — Egyptians candied fruit and nuts in HONEY

a.d 1498 — First toothbrush, made of Hogshair. CHINA

1500's — Lead and cork used in toothfillings

1850's — 380 companies in America making candy

1874 — First electric dental drill used

1906 — HERSHEY'S KISSES

1912 — LIFE SAVERS

1920 — Baby Ruth (named after president GROVER CLEVELAND's daughter — *not* the baseball player)

1941 — m&m's

1960 — BLAMMO ← The first SUGAR-FREE gum

1964 — Charlie and the Chocolate Factory – by Roald Dahl

1972 — Sammy Davis Jr. scores his only Billboard #1 hit "The CANDY MAN" written by Leslie Bricusse and Anthony Newley

WONKA BAR

The Assortment

Candyland was full of suitors—I had to interview many before committing to relationships. When I was twelve, I would go to W. C. Murphy's, a vast convenience store on Wisconsin Avenue. My experimentation called for variety, so when I bought candy, I always spent a dollar and bought four different kinds. As candy's would-be bride, I devised my own tradition of something chocolaty, something sugary, something fruity, and something new—to eat too much of one kind made my tongue go raw. I brought home combinations such as Three Musketeers (chocolaty), Lik-m-Aid Fun Dip (sugary), Starburst (fruity), and caramel creams (new). I had it down to a science.

My brother and I agreed that purples were the best. Purple SweeTarts (Giant Chewy), purple Bubble Yum, purple Volcano Rocks, purple Zotz, purple gumdrops (not to be con-

fused with spice drops)—purple was the alpha candy of any phylum. We considered saving all the purples of all the candies into one big purple collection, but it was clear to both of us that I would just eat it in a single day regardless. Still, I loved the idea of so much purple, the best of the best. Strange as it may seem, I never associated the concept of purple candy with the fruit it was designed to imitate: grapes. I despised any and all fruit and refused to eat a bite of it.

During this affair with the assorted candy meal, three friends and I started creating candy cornucopias for each other. I was, naturally, the ringleader. We would each buy collections of candy, sort them, and bundle them in napkins for delivery the next morning to the others. The surprise of unwrapping someone else's composition far surpassed the humdrum purchase of the same selections in the store. It also gave me reason to buy far more candy than I could have justified for myself alone. As I created the gift bundles, I would sample liberally. Then I would place the laboriously balanced napkin lumps into my backpack, where they emitted an intoxicating scent. Often I was compelled to sneak a piece or ten out of one of the designated gifts and then (rats!) I would have to eat from the others to even it out. The next morning, during our first classes of the day, we would devour the goods while our classmates looked on with envy.

I never got sick from eating too much. I had no cavities. I was a skinny kid. I was built for candy.

○

One friend, Laura, had a slumber party in her basement that year. I didn't know by what cultural code the other girls understood which records to buy, or which clothes were cool. So for her birthday gift, I succumbed to the universal urge to get a person what one wants most: I filled an entire large shoebox with candy. A pounder of M&M's formed a base. Smarties were unwrapped and shaken into the mix. Candy corn heads and tails peeked brightly through the crowd. Nerds poured out of boxes like salt into a stew. Swirls of licorice snaked through the rainbow jubilee. Tart 'n' Tinies huddled in clusters. And still-wrapped caramel cubes lumbered heavily to the bottom. As I gazed at my creation, it seemed to me a dream come true.

Later, during the gift opening, I worried that the candy medley wasn't a significant-enough present. But when Laura unwrapped it, everyone oohed and aahed and dug in. The box was passed around, and it wasn't depleted for hours. But as we all feasted, I secretly knew that I was the most enthusiastic. For everyone else this indulgence was a novelty that came and went, but I was acutely aware of where the box was in the room, how much candy remained, and how soon it would make its way back to me. I wouldn't stop eating until it was empty, and feared that someone would notice my single-mindedness. It was the first time I had an inkling that others were easily distracted from sweets by more central events, where for me the distraction of sweets was the main event.

Conversation Hearts

It was the winter of eighth grade, and I thought that I was on the cusp of being discovered by boys. Like a Midwest starlet getting off the bus in Hollywood, I knew that being discovered would change the course of my otherwise dull-looking future. I had been at an all-girls school for over three years and hadn't managed to have any contact with boys. I couldn't even imagine how a conversation with a boy might proceed. When I pictured my ideal encounter, it consisted of an initial dreamy gaze, filled with a silent understanding of mutual attraction, which led immediately to making out. If the interaction required other skills, like dialogue, I surely wouldn't make the grade. Even the concept of mutual attraction was for the most part theoretical. It was hard to tell which boys were cute, so I safely agreed with the other girls. Any boy who was socially acceptable would have been fine by me.

The eighth-grade ski trip was coed. It involved a crack-of-dawn bus ride to the nearest ski resort in Pennsylvania, a day pass, and then the bus ride home. The idea of getting onto a coed bus without a pre-established seating partner was inconceivable, so Lucy and I signed up together, and promised to sit next to each other. I brought a large bag of conversation hearts as our bus snack. Even though we had gotten up ridiculously early for a six A.M. departure, we started in on the hearts as soon as we reached the highway. Lucy kept pace with me, and by the time we had gotten to the New Jersey Turnpike, the bag was empty. The candy kicked in. I felt good. I was ready to hit the slopes. I was black diamond material. But Lucy didn't fare as well. In an almost too-perfect delivery, halfway through the sentence "I don't feel well," she vomited between her knees, onto the floor of the bus. We looked at each other in utter mortification. We both knew that this wasn't just about Lucy feeling sick. This was a social fiasco.

"Please don't tell anyone this happened," Lucy whispered to me as she got up to go back to the bathroom.

As she went, the smell also made its way through the bus. Kids started to yell disgustedly, "Gross! Who threw up?"

Lucy had vanished, and I was now sitting alone with the incriminating, odorous evidence. I was loyal, so I certainly wasn't going to make any announcements, and I knew that any false move on my part would give us away. So I sat reading quietly, ignoring the murmur as Lucy was gradually identified as the culprit. I wouldn't affirm anything. After a while, however, I couldn't help but notice that Lucy still hadn't returned. I peered down the aisle and saw that she

had managed to find an empty seat. Of course this made sense, but somehow I had expected her to return to her befouled seat—to pretend nothing had happened. Now I was stuck enduring her mess, being a faithful friend, alone. She was riding in relative comfort, but under the unrelenting taunts of the other eighth graders. Our position was precarious. We were seriously outflanked. My greatest fear was that the others would shift their attack to me, figuring that because I was the one dutifully manning our original posts, I must have been the perp. I shrank down into the seat. There was vomit underfoot. I looked back at Lucy, and she looked away. She was angry with me, I could tell. For bringing the candy? For not getting sick? I had no idea what I had done wrong, but I wasn't surprised. This was eighth grade, and Lucy was frequently angry for unpredictable reasons. I closed my eyes and waited for it all to be over.

So much for being noticed by the boy creatures. The romantic promise of the conversation hearts was a complete flop. There would be no conversations with boys, not even polite ones—not even any eye contact. There would be no cartoon hearts sketching themselves between my profile and that of a young lad. Discovery was elusive.

In spite of my success rate, which hovered constantly at zero, I was to stick with my fervently silent strategy for meeting boys for all the remaining years of high school. In fact, that morning, when I sat for hours trying to hunch into invisibility, was probably the closest I ever came to being discovered.

Spree

I was going to be fat. I was going to be sick. I was going to get cavities. I was already getting fat (I wasn't). My mother tried all tactics to curb my habit. No matter, I may have had to be home by curfew, but I could eat whatever candy I wanted. A teenager can make her own decisions. Nonetheless, the quantity I consumed was often so vast, so embarrassingly inhuman, that I could not bring myself to eat it out in the open. During October, I ate an entire pound bag of candy corn, or miniature pumpkins, on a daily basis. In February it was a pound bag of conversation hearts. By March there was Easter candy. In those months of heavy consumption, I would spend hours reading in bed and plowing mindlessly through acres of sugar.

Bulk consumption of candy was not all it was cracked up to be. There was an initial thrill, as the candy delivered on its promise of immediate, unqualified sweetness. Then, after

the first few bites, came the secondary pleasure of indulgence. This was combined appreciation for the texture of the candy and recognition that the supply was good—there was plenty more. Finally, I would succumb to mechanical consumption. Taste lost relevance. The rapture receded, and I just kept going. When I had eaten so much that my mouth grew thick with sugar and I couldn't swallow, I would drink glasses of water or milk—skim, ha!—and then return to the task at hand. By the end of a bag, I would slip into a sugar coma, a hallucinogenic slumber as my insulin spiked and sugar level crashed.

Somehow I could not bring myself to throw incriminating wrapper after incriminating wrapper in the small yellow wastebasket that matched my desk. Instead, I pushed the evidence between my bed and the wall, down where trouble disappeared. But this was a time when my mother changed our sheets every week. In the course of doing so, she would move the bed out from the wall to tuck in the sheets, discover my trash trove, and express her disgust. She had given up on disciplining the candy habit. All she did in response was to say, with weary disappointment in her eyes, "Hilary, please use the trashcan. I'm not going to throw away your wrappers every week."

But I couldn't bring myself to do it. I always hid the candy. When I read, I propped myself up against my headboard, with my knees crossed and the book leaning against them. I kept the candy under the covers. When I went down for dinner, I would leave the book splayed out with the candy huddled beneath it.

One time I was eating a Cadbury egg. These eggs were new discoveries, and I loved the sugary goo that was meant to represent raw egg. (I wouldn't discover the beneficial effects of refrigerating Cadbury eggs until much later.) I generally ate three at a sitting. On this particular day I was relishing the first egg of the season with such focus that my ever-present book was upside down against my knees. My mother came in without knocking, saw the upside-down book and the heightened look on my face and apologized for her intrusion. I could tell that she thought I had been reading a dirty book that was hidden behind the upside-down one, or otherwise exploring my adolescent sexuality. I let her believe what she would. It was better than the truth.

Later, in college, I would inherit a desk from my brother. Eric was always the sane one. His desires were reasonable. The candy he liked was always either tart or sour. Spree were his favorite early on, and he rarely ventured beyond them. I admired his commitment to Spree. It was a candy with good personality. The name was cheerful and energetic. Most admirably, he would make a pack last several days.

I never bought furniture in college, I only scavenged what I could from the street and friends who were graduating or upgrading. My roommate Kate and I carried my brother's lightweight desk to our new off-campus pad. I opened the drawers. They were all empty except one, which revealed a secret: hundreds of pristine, but empty, Spree wrappers. They lay there like discarded snakeskins. My brother, it turned out, ate a whole lot of Spree in the course of the year. He had diligently worked his way through a roll

at a time, careful not to tear through the paper. Kate began to laugh. "He's just like you!"

I could see what she was getting at, but I disagreed entirely. Much as I admired the delicacy and ritual with which he approached his task, I knew full well that our approach to candy was very different. For my brother it was an idle desire that he occasionally fulfilled. For me it was constant. It was interwoven with emotions, with secrecy, with illicitness, and with the ever-present shadow of future weight gain. Once I was an adolescent, my mother gave up on forbidding candy consumption. Instead, she tried to stop it with the only reasoning she thought might have any effect on a teenager. She frowned disapprovingly and reminded me over and over again that I would be fat. Even if I wasn't now, my metabolism was about to slow down and then I'd see.

My mother ate nibbles of fat-free matzo for breakfast. I never saw her eat anything else.

Any year's assembly of my wrappers would be a far different vision from the orderly collection that Kate and I had found in my brother's desk. It would be torn, hurried, multicolored, mixed, and spread out. Smarties wrappers would fraternize with Swedish Fish bones. Boxes of Nerds would battle it out with Lemonheads. Reese's Peanut Butter Cup wrappers would linger on the outskirts, scandalized by chocolate's underrepresentation. The candy detritus of my lifetime would be a sight to see.

Bottle Caps Nostalgia

Candy is a food group. Those of us who give candy its due respect as a food understand that it isn't really possible to have a favorite candy. Hungers vary. One wants something rich, or chewy, or tart, something chalky or plasticky. One has seasonal or on-the-spot cravings. One simply must have a Starburst, and must have it now. But everyone has a front-runner, a desert island candy, the candy that one will never refuse. For me, this is Bottle Caps.

Bottle Caps are round sugary tablets, like SweeTarts, but they are "the soda pop candy," coming in cola, root beer, grape soda, orange soda, and cherry soda flavors. Bottle Caps are not easy to come by. They aren't in most East Coast drugstores or candy stores, although they aren't above making appearances when you least expect them. The lack of Bottle Caps distribution may be the reason I go overboard when they are available. The rarity gives me an excuse to

purchase as much as I might ever want—for the rest of my life!—because who knows when I might find them again.

This enthusiasm is not exclusively a nostalgic response. Candy nostalgia is easy to identify. Walk into a crowd and say, "Do you remember those candies they used to have when we were kids? My favorite was . . ." This is always a conversation starter. People are passionate about candies that have disappeared, like the Marathon bar, even though its British twin, the Curly Wurly, is allegedly a fine substitute. For these people candy represents the less-bitter-than-sweet days of ephemeral youth. They reminisce with the same dull choruses that they use to chant the plots of childhood sitcoms, cherished memories whose value comes exclusively from the fact that they are no longer current.

Still, I confess to feeling some nostalgia for Bottle Caps. Even when I was in junior high school, I located a Bottle Caps source and was excited to learn they were still being produced. One summer in the heady pre-Rollerblade days, my friends and I went crazy for roller skates that had sneakers instead of the classic white ice-skating boot. Who cared that the risk of breaking an ankle increased dramatically when one wore these skates? Carrie, Lucy, and I spent a whole summer on skates, breaking our downhill speed with tree trunks, cars, curbs, pedestrians, or whatever else happened to be there. One day we skated down to the National Zoo. It was a hot day, and we stopped in the deli across the street. To my great delight, they stocked Bottle Caps. They were packaged in theretofore-unseen rolls, the way the long-lost Wacky Wafers (Sigh. I loved them, too.) were sold then and Spree are currently packaged. Thrilled, I bought four

rolls on the spot. The zoo—and that deli—quickly became my favorite skating destination. I would buy seven rolls at a time, four for myself and three for my brother. I would finish mine in a day and then start stealing his, which was okay because I had given them to him in the first place.

But to ascribe my Bottle Cap passion to nostalgia alone would be wrong. People can *madeleine* away for all I care, but that's not what's going on here. Bottle Caps deserve attention on candy merit alone. Most candy is chocolate- or fruit-flavored. Chocolate is a primary flavor, a natural food. Fruit candy is a secondary flavor—candy made to taste like a natural food. But Bottle Caps have neither primary nor secondary flavor. The genius of Bottle Caps is that their flavors are artificial flavors representing artificial flavors. Bottle Caps simulate root beer and cola beverages, which are already weird chemically manufactured flavors. Even the orange and grape Bottle Caps are genuine efforts at creating the taste of orange and grape soda, which are themselves approximations of fruit. Bottle Caps have tertiary flavor. This puts Bottle Caps in a rarified league, keeping company with the likes of bubble gum ice cream; certain Jelly Bellys (there is not only a lemon Jelly Belly, but also a lemon drop Jelly Belly), and some easily dismissed popcorn varieties. In the competitive world of layered flavor allusions, Bottle Caps may not have the biggest market share, but they have a dedicated following of at least one.

Any Bottle Caps sighting became a reason to rejoice. On a weekend visit to Rhode Island I found a newsstand selling the green packets—this was before the new purple version—and instantly bought twenty at ten cents each. There

was always a moment of glad discovery when I first saw the familiar packaging; then I would proceed to purchase a massive quantity, usually in multiples of seven. If I were trying to be moderate: seven. If it had been a while: fourteen. If I knew there was zero chance I would be able to return to the store to stock up: twenty-one. Whether I was a passenger in a car, or at home reading the paper, consumption followed a defined ritual: I poured an entire pack (usually about twelve pieces of candy) out into my hand. The lesser flavors—orange and cherry—went first. Then came the three lead flavors—cola, root beer, and grape—one at a time.

I do not suck or savor. I chew. I cannot understand those who do not chew. It is all about chewing. There is no flavor in suck. There is no instant and total immersion in the fine taste and texture. Sucking, they say, is about postponing gratification, about accepting less for longer, drawing it out. But if one wants to prolong the ecstasy of candy, it can be done easily not through sucking pieces, but through eating mountains of them. Why savor less when you can just buy more? I like lots of Bottle Caps; I like them all at once; I like to tear through them, fast and furious, and then to collapse in sated exhaustion.

Bottle Caps, as my premier candy, have nostalgia value; they have candy merit; and they make for a fine ritualistic snack experience. But most potently, as I was to discover, when a good thing comes along, memories have a propensity for attaching themselves to it.

Tessana's Butterfly Cake

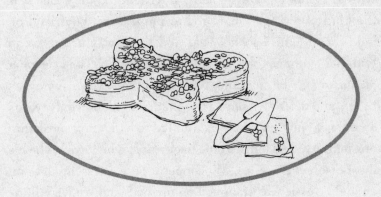

When I arrived at summer camp, I was fourteen, my acne was at its worst, and my hair was lumped into four wacky braids, which stayed in place without rubber bands because my hair was so wiry. For the first day of camp, I had chosen to outfit myself in a new red T-shirt with sleeves that rolled up black. I had a matching black-and-red pin with the *Rocky Horror Show* lips on it above my (just forming) breast, and a pin-striped jean jacket.

Jessie was the first person I met. She had auburn hair, a perfect nose, and a dancer's body. She wore Secret spray-on deodorant and Jean Naté body splash. Taking one look at me and the other two girls with whom she was supposed to live in a platform tent all summer, she told us, "No offense to you guys, but I'm going to ask to be moved. It's just that I'm older than you all, and I'm not sure this is the right tent for me."

What she meant was that we weren't cool enough for her. I was not surprised. Girls like Jessie weren't friends with girls like me. Jessie had a boyfriend, Danny. She was the kind of girl who managed to put a camp boyfriend on hold for an entire school year and then to return to camp with her summer romance pre-packaged. The coed sleeping arrangements of our camp were such that Danny, who was blond and friendly, slept in a platform tent twenty yards away. That first night, Jessie wanted to let Danny sneak into our tent. My bed blocked the back flaps, which would be his most discreet entrance. My cooperation was essential. Soon enough, Jessie was stationed on my bed, and we were hurling rocks and tree bark into the night to get Danny's attention. By the next morning, I had two new friends, a silly nickname, and Jessie had decided to stay in our tent.

Jessie thought I was hilarious. She told me so, and she made it clear to everyone else. This was unprecedented. Here was the prettiest girl in camp, with the cutest boyfriend, the girl whose wardrobe most closely resembled that of Jennifer Beals in *Flashdance*, and she had chosen me. I lay awake while Danny and Jessie fooled around in the darkness of the tent, our other tentmates oblivious or silently furious. Sure, they were making out between talking to me, but I was content to be their chosen third.

"Should I go all the way with Danny?" Jessie asked me one day. I had never kissed a boy.

"I don't think so," I said. "Aren't we too young?"

I, too, was in love. Our counselor, Finn, who was a crazily ancient nineteen, had taken an interest in the journal

that I kept religiously. I let him read what I wrote, starved myself (or pretended to), and did anything else I could think of to get his attention. Actually, there were two journals that I kept simultaneously: my regular journal, and a censored version of it for his perusal. We took silent walks together, and he issued cryptic statements that might have meant that he thought I was fascinating and/or nubile. He had a counselor girlfriend. My love for him was forbidden. It was a great secret that I harbored and nourished with every ounce of fantasy I could summon.

My fifteenth birthday fell in the middle of August. By then I had fully asserted a brand-new personality. Back in high school I might have been an awkward loser. Not so at camp. At camp I was outgoing and silly, with a private dark poetic side that no one could possibly understand. Things were going very, very well.

Early on my birthday a boy I had scarcely noticed came up to me. "I hear it's your birthday," he said, handing me a plain Hershey bar. He was on kitchen duty, and he had stolen it for me. It dawned on me that this boy, Rob, had a crush on me. I was not interested. I had bigger fish to fry, utterly preoccupied with the nineteen-year-old Finn.

That night, the evening activity for the older kids was a ghost story being told in the Tent Pavilion. I was told I had received a phone call and made my way across camp to the telephone in the office, but when I got there the line was dead. We were in the hills of New Hampshire. These things happened. I was late to evening activity. When I approached the Tent Pavilion, it had gone dark and utterly silent. This, I figured, was the warmup for the ghost story. I found my way

down the path without a flashlight, and the door creaked open.

The lights flashed on, and there was the entire tent unit—the older kids—gathered in my honor. It was a birthday celebration the likes of which hadn't been seen all summer. In the center of the Pavilion was an enormous cake, shaped like a butterfly and covered with Starbursts, M&M's, red-hots, and gumdrops. The entire tent unit sighed in wonder. It was a beautiful cake. Tessana, a white-blond, deeply tanned art counselor who had a British accent and thrilled Danny and the other boys by sunbathing topless, had made it for me. I was clearly the unwitting beneficiary of her artistic boredom. But that cake fed the most glorious moment I could imagine. Never, never had I received extra attention like this from my peers and leaders, or felt recognized as being interesting or funny. My camp personality was solid. They knew me, they liked me, and they were rewarding me with a cake-load of candy. It was the best cake I had ever tasted. It was the birthday of my dreams. My fortune had turned. Today was like that butterfly, unimaginably fluttery and sweet.

Later, after the cake, I lingered on the little deck of the male counselors' tent, listening to somebody play guitar. I sat with my arms around my knees, seeing what my tent looked like from Finn's perspective. It was cool in the mountains, and my sleeves were pulled over my hands for warmth. Finn was behind me in the tent. I heard him say to another counselor, loud enough for me to hear, "She's fifteen tonight. Three years. It's a while to wait, but it's worth it." My face didn't

change. I rocked a bit in my curled-up position and chanted his words silently in my head, committing them to memory for future parsing. It was impossible that he had said such a thing, and yet I had heard it. Three years, three years, three years. It was a storybook statement, and I couldn't believe that it hadn't emerged from the force of my fantasies, or that he wasn't saying it to torture me. But there it was. I walked away from the tent, went directly to my journal—the uncensored one—and wrote it down. In code. I both knew exactly what it meant, and couldn't allow myself to believe it had been said. I asked my journal, "He says he's waiting for me, but what could that mean? Could it mean that he loves me?" If I'd had one grain of guts I would have turned to him and said, "What do you mean—are you talking about me?" But I was fifteen. My capacity was limited.

When I went back to high school in the fall, I was still the same caterpillar—a short girl with frizzy hair and unfortunate clothing. Instead of transforming me into the popular butterfly I so desperately wanted to be, the magic of summer camp taught me how to dream the impossible dream. I pined for Finn. He consumed my consciousness. Whatever interest he had taken in me was far outweighed by the volume of my obsession with him. I fed myself the hope that he would love me the same way I gorged myself on sweets. I copied love sonnets out of books into my journals. The small pieces of him that I remembered were magnified into my taste and personality: If he had mentioned an album or a book, I bought every work in the creator's oeuvre. When I first kissed (a friend's forgettable cousin visiting from New York)

all I thought was, Now I will be ready for him. I drank whisky thinking, When I am with him I will have to throw it back and smile. The mailbox was a silent, open mouth. I sent thousands of letters to him and counted the words in whatever occasional notes he sent me back. Every day I walked out the door to my house expecting to see him there, because I knew that when the call of true love telegrammed itself across distances, it was eventually heard and heeded. As I walked to school, I chanted our names, one letter for every pace, driving them into the ground like curses. On each typewriter my fingers would find his keys, hurtling dense telegrams onto the bare platen. If once I had been open to the notion of spirituality and hopeful that a higher power might notice my plight (lonely teenage girl among other lonely teenage girls), now all my elevated passion was devoted to feeding my secret love for Finn. Had I not been at an all-girls' school, had I not still been so shy and self-conscious, maybe real life would have interrupted this sustained fantasy. But it didn't, and I would go on like that for years, until three years had passed, and Finn determined that my metamorphosis was complete and made good on his insinuations of our future.

Mints

M ints are not necessarily candy. In fact, the most crit-
ical defining factor for a mint is where it falls on the
mint-candy/mint-but-not-a-candy continuum.

MOST CANDY

Junior Mints
Peppermint Patties
Frango Mints
Mint nonpareils
Mentos
Violets
Candy canes
Starlites Mints
Certs
Breathsavers
Tic Tacs
Velamints
Altoids

LEAST CANDY

The qualities that determine placement on the continuum are: whether they are better chewed or sucked, whether they can be consumed in bulk quantities or are delicately savored, concentration of flavor, and whether their primary life goal is to improve breath or to bring joy to the consumer.

As far as this consumer is concerned, why ever dip south of Mentos?

Nonpareils

Halfway through high school I joined the track team. It was the only team that a person without any skill or talent could join and receive varsity credit. I did it because it would look good on my transcript for college. There was an arduous price to pay. We ran up to five miles a day. I brought nothing in ability to the team, so I tried to entertain them. I figured out shortcuts for those who didn't want to do complete runs, and calculated the time it should have taken to run the full distance. I kept an eye out for the coach while smokers sneaked cigarettes between races. I brought sweets to meets.

The meets were always far away in the suburbs of Virginia or Maryland, and we were stuck there for hours on Saturdays. My race was the 880. It wasn't long distance, and it certainly wasn't a sprint. It was a good race for people who were bound to lose. On one sunny spring morning we arrived at a meet around noon. It was hot. I brought a large

bag of mint nonpareils. They came in pink, green, and yellow kisses, and tasted like white chocolate, with just the right tinge of mint and a light crunch from the delicate white sprinkles. I usually waited until after I ran to indulge, but this time I couldn't resist. And once I started, I couldn't stop. Mint is no marathon candy. It has a point of exhaustion, and I jogged right through mine. As a sluggish sugar low descended upon me, my race came up. In a fog, I plowed through the half-mile, hating those mints every step of the way. It is hard to say if my performance was worse than usual—I was in the middle of the pack, as always. But afterward I lay down on the bleachers with an unpleasant thickness in my mouth. It would be years before I ate another mint nonpareil.

As my love-hate relationship with candy has evolved, I have contemplated whether my insatiable desire comes from sugar's nefarious insulin game—the energy-jolt-and-crash that demands more fuel—or from a misplaced urge for the missing "sweetness" in life. If it is the latter, then the greater satisfaction I find in life, the less I should desire candy. But if I am simply under sugar's spell, there is some hope that eating enough candy will lead to permanent disgust—the way people say, "I can't drink tequila. I had a very bad night in Cancún." If I could just have my last hurrah with candy after candy, I could eliminate them one by one until all hunger for sugar was gone. Then the battle between health and desire would be resolved, not through deprivation but through exhaustion.

I never see those pastel mints without remembering that track meet. One down, hundreds to go.

Skor

It was a short affair, and no one ever knew about it. I have no idea how we were introduced. One day you were just there. We met every day for three brief months after school, in private. You didn't last long, but I didn't expect you to.

Jelly Belly Jellybeans

I have a fondness for cheap drugstore jellybeans, the kind that come in two-for-a-dollar bags alongside butterscotch disks and spice drops. The sugar shell of the cheap beans is thicker, so there's a better ratio of shell to bean. But Jelly Belly jellybeans have their merits, particularly the freedom they give you to select from fifty official flavors plus new "rookie" flavors. The Goelitz Confectionery Company, which survived two world wars on its candy corn business, renamed itself Jelly Belly after striking it rich with the flavored beans. At last count, they were manufacturing about 40 million beans per day.

When I was a junior in high school, Lucy invited me to join her family on a trip to Hilton Head, South Carolina. We hadn't had a falling out exactly, but I had recently made some new friends, and so had she, and we were spending

less time together. The exclusivity (whether by fate or design) of our earlier friendship was eroding, and there was some tension because of it. But there hadn't been any grand teenage scene, with accusations and tears, so it looked like we might weather the change. Hilton Head sounded fun, and I liked her family too, so I said yes.

The whole island was a resort, or maybe this was only true as far as we explored. For some reason there were few people around. Maybe we were in a private area of the island; maybe it was always like that. Small alligators lumbered across our paths as we biked down narrow walkways. We went to the beach every day in glorious beach weather. We lay on towels to bake ourselves, determined to get as dark as we could. I listened to "Born in the U.S.A." on my Walkman, again and again, and every time I flipped from one side of the cassette to the next, I rolled over on my beach towel, keeping an even tan. After some hours of this we would go to the ice-cream store. I would buy a scoop of mint chip and a quarter pound of Jelly Belly beans. At first, we bought assorted flavors. But after a day or two we knew what we liked and were selective. I only bought root beer and lime. Lucy chose pink grapefruit and cherry. As we biked home, I kept the bag crunched in my hand, eating two or three at a time when we stopped at street corners.

At some point near the end of this theoretically blissful week, Lucy decided that she was angry with me and stopped speaking to me. I was indignant. We had been doing exactly the same thing every day—lounging by the beach. There

simply hadn't been any opportunity to make a stir. Certain that I had done nothing in particular to incur her wrath, I was annoyed by her irrationality. A day passed. At dinner her parents noticed our silence and teased us. I shrugged at them and rolled my eyes.

"I have no idea what my latest offense was," I told them, embarrassed at our youth and hoping for allies.

The next day I went to the beach alone. When I closed my eyes, I could make my teenage troubles disappear. The world turned and remade itself with a new-found exuberance. I was suddenly free of tanning oils and self-consciousness, free of being a teenager. The earth's solidity and timelessness came rolling forward on the ocean. I was reading junky philosophy and imagining that it had changed the way I saw the world. I made notes on my obser-vations and identified my own weaknesses and how I thought life was properly lived. There had been slaves on this island once. I wanted to immerse myself in plantations and spirits and history. Leaving the beach, I biked deep into the woods, got myself lost, felt heroic and wild.

It was for the camp counselor of my obsession that I wanted to be complicated. For him, I would propel my thoughts onto higher ground, keep silent in hope of appear-ing enigmatic. Two days before leaving on the trip I had got-ten a surprise visit from Finn. I replayed the vision of him on my doorstep in my head, how he had winked at my mother when he told her I was safe with him. How he claimed that he had lost my phone number so he'd had to drive all night from New Hampshire to find me. What in heaven's name

was a high school girl supposed to do with that but fall for it, hook, line and sinker?

We had spent the day together, visiting the national monuments and wandering into bookstores. My wish had come true. My love had come to me. Because my fantasies had never gone beyond imagining this sudden appearance, I had no plan for how to behave. It was overwhelming, and I was mute with disbelief. Although I steered us to romantic settings, I was incapable of revealing my devotion to him. All I could do was stare into his eyes, hoping to communicate the depths of my emotion.

I was much better at remembering the visit than I had been at conducting it. Hoarding time by myself, I mooned; I sighed; I felt insignificant; I was all about being in love. This was where I found real pleasure—not in vacation, but in the romantic reveries that Finn fed, and would continue to feed.

On the way home I bought jellybeans for myself and for Lucy. No matter how over-romanticized my visions were, I wouldn't forget my dose. My boy of choice was elusive, but at least I could select the bean of choice from the Jelly Belly canisters.

Apparently, Lucy had been seething all day. She accused me of "using" her to come to Hilton Head. I responded coldly. I couldn't be bothered to summon respect for her position.

"I'm sorry you feel that way," I said. "I'm really not in the habit of going on vacations with people I don't like." I handed her the jellybeans and read my book until she gave up.

I Know What You're Thinking . . .

Whatabout tooth decay, weight gain, acne, diabetes? I don't want to talk about any of those things.

Fruit Slices

When I got my first job, I shot the moon. During my junior year of high school I began working at an ice-cream store in Georgetown, behind the chocolate counter. The poor, unsuspecting guy who hired me didn't even bother to instruct me not to sample the goods. It did not occur to me to try to control myself. *Au contraire.* Here, finally, was the unending chocolate fountain of my fantasies.

The merits of chocolate are well documented. None of them passed me by. Chocolate is a no-brainer. Cheap or expensive, alone or with filling, chocolate has such a full range of executions that it suits any occasion. Many of the candies I exalt are unique combinations of texture and sweetness, with flavor as an afterthought. Chocolate stands alone. It is a flavor and a candy, which is more than a peanut can say for itself. Chocolate is universal. Rivers of chocolate flow in every child's dreams.

At the ice-cream parlor I had limitless plain chocolate, caramels, turtles, white chocolate, mint chocolate, cream-filled chocolate. I only excluded dark chocolate (too bitter) and chocolate-covered strawberries (since I hadn't yet come around to fruit as edible). I sampled in unquantifiable amounts. It was a lot of chocolate.

Every day I began with a robust hunger for the contents of the chocolate counter, but the longer I worked in the store, the lower my daily chocolate tolerance fell. Ultimately, what could I do but turn to candy fruit slices? The yellow, green, red, and orange jelly fruit slices, dusted in sugar, were fruity and refreshing. I ate them ceaselessly, restocking them when necessary. Under my watch, the tray needed to be refilled at least once a week. Nobody ever bought them. I may have had no lunch break, but I was eating fruit all day long.

I was just beginning to see that my candy consumption wasn't ideal, and I thought that by working in a candy store, one of two things would happen to me. Either I would tire of candy, or I would get fat. There was always an undercurrent of hope that one or the other would happen, driving me away from the compulsion of the habit, and leaving me with a more refined candy-eating style. Instead of getting bored with candy, however, I just got bored with the job (and was forever terrified that I would give someone the wrong change). And instead of getting fat, I hovered at a weight that my mother thought was a problem, but she was a size zero.

I wasn't entirely happy with my body, and I was worried about gaining weight. I was aware that the fruit slices were almost entirely sugar, and therefore potentially less fattening than chocolate. This knowledge may have even contributed

to the development of my candy tastes. I always went for the most sugary selections, which tended to have almost no fat. But I made up for that in sheer caloric content. I knew, because my mother had ingrained fundamental diet principles early on: Excess calories convert to fat. My mother had told me that I should have three diamonds of space between my legs when I stood with my feet together: one above my ankles, one between my calves and my knees, and one between my thighs. As far back as I could remember, I had never had the thigh diamond. My mother was certain that it was mine to gain. But I wasn't motivated to diet or exercise. I was a teenager, and my metabolism was still doing me a few favors. My stomach was flat. My clothes fit me. I was neither thrilled with my body nor unhappy enough to sacrifice candy.

So I snacked through my work hours, and even brought home boxes of candy for after dinner, when my sugar appetite reawakened. I was not the best hire the sweet shop had ever made. When they failed to send my last paycheck, I couldn't bring myself to complain. It had been idyllic. I owed them.

Fudge

Lauren and I were close friends, and had both won an essay contest that sent us to Oxford for six weeks the summer before our last year of high school. We arrived at New College in Oxford in a daze of excitement. Our rooms were next door to each other, like real college students. Lauren was already collegiate. She carried a Filofax in which she kept meticulous track of all her expenses. She was intelligent and studious, with varied interests and talents. She was tall and slender, with glossy brown hair and alert brown eyes. The preppy clothes that were popular then suited her, while their tailored lines went to war with my curves. No question about it, Lauren had her act together. On the other hand, when I imagined my trip to England, I fantasized about taking advantage of the drinking age (sixteen), and finding a college-age boyfriend with whom I would make

out on narrow, charming streets and in the dorm room where I would have unprecedented independence.

I was still mousy. I had been at an all-girls school for many years, and couldn't talk to men. Not a single word. After lunch in the dining hall Lauren would go to the library to study, and I would wander through town, in and out of bookstores. Every day I bought homemade fudge at the "tuck-shop." The origins of fudge, invented at the turn of the twentieth century in the United States, are debated. Most fudge historians agree that it was the result of an error in making another candy, probably caramel. I saw no evidence of error.

I would eat the chocolate fudge in my drab room, or in the library, summoning as much inspiration as I could to study for my Shakespeare class. When the tuck-shop ran out of fudge, overwhelmed by the sudden run on their supply, I checked in on a daily basis until they restocked. Alone in my room, I broke off small pieces of fudge with my fingers, staring out at the impeccable summer lawns in disbelief at the untapped romance of my life. Every night I went to pubs with Lauren and others on our program, and after several drinks I would gradually join the conversation. I had a crush on one of the college boys, Tory, who was the stretched-out version of a dashing soap star. After some time Lauren and Tory began to date. This I accepted. Sure, she had a boyfriend at home and I had no one in the world. But a person who couldn't communicate in daylight hours had no business expecting her friends to honor her crushes. Lau-

ren and Tory were kind to me. They let me entertain them with imitations of the others on the program, then excused themselves for "naps." More fudge.

While at Oxford I never really saw that I was purposeless and lonely. All I knew was that I was disappointed that drunk young men weren't climbing through my bedroom window, and that the only men I was friendly with were not romantically interested in me. This was all that mattered at the time.

The details of that trip became irrelevant. A week after Lauren and I flew home, she traveled to a Montana ranch to visit the boyfriend she had left behind. I went to the Maryland shore with a family as a babysitter. Two days before my seventeenth birthday I got a call from a friend. On a highway somewhere in Montana, Lauren had been in a fatal car accident. I stayed calm. There were kids in the room. I called my mother, cried quietly, and made plans to go home for a memorial service. My mother told me that there was a birthday card that Lauren had sent waiting for me at home. That was very like her—to send a card right on time. I was strangely glad to know that it was there, to know that I would receive some last words from her.

The family I was staying with at the beach was going on a boat ride. They convinced me to come along, telling me it would be better than sitting at home alone. On the boat I made a list of every single thing I could remember about Lauren and what we had done together. The significance of the pieces of our trip that were mine alone curled in on

themselves like old leaves. There had been no crush on Tory that had evaporated into silence. There had been no long, empty days interrupted only by the short-lived thrill of the tuck-shop. My solitude evaporated into nothing. In my efforts to preserve my lost friend, I polished everything we had shared to its shiniest.

When my senior year of high school started a few weeks later, I was somewhat in the spotlight. A member of our small graduating class was missing, and I had the cachet of having spent half the summer with her. But I was determined to mourn Lauren privately. I wasn't interested in sharing my memories, or in how much my classmates might miss her, or in anyone's support. I didn't want to wear black, slam doors, and have people feel sorry for me. Instead, I felt a surprising lightness. All the trivialities of high school, all my insecurities, self-consciousness, and dread, had dissolved overnight. Not only had I stopped caring what anyone thought of me, but I felt warmly disposed toward all of my classmates. For the first time I understood what it was to feel simply open and friendly without worrying about who my friends were and who they might be the next day. Now, when I thought about the tuck-shop, and those long hours spent eating fudge and pretending to read, the loneliness was insignificant. That was the life before, and now I knew what it was worth.

Snickers

It was end of high school, and before I started my summer job I went on a school-organized canoeing trip. We spent two weeks in the Southeast, driving a van from river to river. It rained on and off most of the time, but I got claustrophobic sharing a tent, so instead I would pitch a tarp and pretend I wasn't getting wet. One of the group leaders, whom we called Muck, shared my dislike for tents. We would lie under the tarp and, as drops of rain angled in under its sides, tell each other that it was just yesterday's rain shaking down off the trees.

This itinerant interlude suited me. My parents were packing up our house in D.C. and preparing to move to a tiny apartment in New York City, where their marriage would soon unravel. I was starting college in the fall and would spend the rest of the summer earning as much money as I possibly could. Paddling whitewater for two weeks was

my last chance to be a kid. I wasn't strikingly good in a canoe, but I loved it more than any activity I had ever experienced. The rivers were alternately calm and rapid, essing through southern landscapes then dropping precipitously as we paddled for our lives. I was dirty, tired, and jubilant.

Somehow I had missed the critical piece of information that food was not included in the trip. I just assumed that we would be camping out, cooking spaghetti and eating gorp. Instead, we were alternately camping and eating fast food wherever we could grab it on the road. I had about forty dollars with me, which I made last a week, but then I was broke. My fast-food choices had been less than nutritious before I ran out of money (milkshakes and cheeseburgers—in that order), but they fell even further when I started to borrow money.

Snickers was the answer. I skipped breakfast. Lunch was usually a group-sponsored carbohydrate-heavy picnic on the riverbank. But after we came off the river, when I was starving from a full day of canoeing, Snickers fulfilled the promise of its ads. It was the candy that ate like a meal. Strong enough for a man but made for a woman. Now, I am not overly fond of nuts in chocolate. Nuts are a whole other food. But Snickers gets it right. Nougat is a staple. Just as bread rounds out any meal, nougat softens the impact of the peanuts in Snickers. Caramel moistens the nougat. The chocolate coating pulls it all together. In Texas, in 2000, a jury sentenced a man named Kenneth Payne to jail for sixteen years. His crime: the theft of one Snickers bar. Apparently, it was a king-size Snickers. Oh, and also the guy was a previously convicted felon. I was glad when I heard that his

conviction had been overturned and he would only face a maximum of two years at retrial. Still, Kenneth, my heart goes out to you.

Looking back, those two weeks encapsulated the best of both worlds. I had the decadence of a child—an all-candy diet and no need for food, clothing or shelter. And I had the independence of an adult—to choose my proverbial path down the river propelled by my own strength. I wasn't exactly at the top of my game. It had been muggy and humid, and we hadn't showered often. My all-sugar diet wasn't designed for long-term sustenance. But I relished the temporary disorder. When we arrived back in Washington, I was hungry and covered with a layer of filth. It wasn't until I stepped off the bus that I realized that my parents had no idea when I was coming home. On top of that, I'd forgotten my keys and was locked out. I had to start my summer job in New York two days later. I picked up my backpack and walked toward home. Still no answer. I knocked on Lucy's door, and her mother hosed me down before she would let me in the house. The dirt ran off me, and I watched a part of my life run off into the ruts of Lucy's patio. The spray of water was as cold as the Nantahala River, and I didn't mind.

Junior Mints

The summer before I went to college, my former camp counselor Finn called drunk from a bar, announced that he had broken up with his fiancée, and wondered if he could see me. I was staying with my parents in New York City, working a miserable administrative job for a law firm in the World Trade Center. They put me in a windowless file room, sorting the papers on a pro bono case. Every day I would buy a box of Junior Mints for lunch-dessert and eat them all as I read *Love in the Time of Cholera.* Sometimes I would lock the door of the file room and read into the afternoon. If any of the lawyers came down to look for a file or to check on me, I would tell them that I was afraid to be alone in that deserted part of the office. Their faces said that the room reeked of sugar and deceit.

○

The night that Finn visited conveniently happened to be the only night of the summer that my parents were out of town. It was also the night before my last day of work. The map of the city was still a jigsaw puzzle to me—scattered pieces that, with only slight attention, would soon be assembled. I meant to bring Finn to the East Village, but I turned us the wrong way coming out of the subway. We were near Washington Square, but at the time it seemed like a vast residential neighborhood with no restaurants to be found. We went to Dojo's, a cheap college joint, and drank pitchers of sangria. Finn told me about his failing relationship. He was as I had remembered him: sincere, but enigmatic, handsome, charming and seemingly convinced that I had grown into the woman he had always imagined I would. I was wearing Birkenstocks. The toilet in the women's room was broken and had overflowed, but I used it anyway, being thankful in my drunken way that the soles of my shoes were thick enough that the flood on the bathroom floor hadn't reached the level of my bare feet.

On our way uptown Finn, to my disbelief, bought a six-pack. He sat in the rocking chair in my room, smoked a joint, and drank three beers. I had a shot of whisky and promptly fell asleep on top of the covers of my single bed. Some amount of time later—maybe two minutes, maybe an hour—I awoke with a start and realized that this night, this night that was literally drunk with opportunity, was going to slip away. Finn was sitting exactly where I had left him, drinking the last of the six-pack.

"I thought we had lost you," he said, apparently not fazed by the possibility.

"No," I said, with the astounding verbal capacity that hits me at two in the morning, on a Thursday night, after several rounds. I walked to the side of the rocking chair to kiss him, but found that I was too tall to do the deed. Had I any experience or innate grace, I might have pulled him to stand. Instead, I found myself kneeling next to the rocking chair. It rocked forward. We kissed.

"I never would have touched you first," he said, removing all of my clothes in one gesture.

"Oh, aren't you the gentleman," I said. "You just got me wasted."

He stopped and put his hands on my shoulders. "Look," he said, "I'm trembling. I'm not too drunk to know that I have wanted this for a long time."

"Okay," I sighed into his neck, "but right now I have to sleep."

 The next morning we walked the family dogs together.

"In return for your room last night," I said, "you are the scooper."

Back in the house, we sat on the couch. I leaned against his shoulder, falling back asleep. I woke to his fingers creeping up my skirt. He still wanted me, I realized with surprise and delight. It was morning and he still wanted me. Names ran through my head—the names of all the people who wouldn't believe that this hopeless adolescent love was actually coming to fruition. Years of pining were being rewarded

with flesh and blood. My imagined prince, the face that had been my fantasy boy prop for all my adolescence, had come, had let me seduce him, had sobered up, and still wanted me. Jessie, my friend from camp, had to be notified immediately, not to mention the tenth-grade English teacher who had used my case to define "unrequited" to her class.

As he kissed me, I realized that my half-dry hair was plastered to my head on the side that had been on his shoulder. I would not make a fine impression on my last day of work.

We eat Junior Mints in the file rooms of the summer jobs that come and go. We eat them with popcorn until we are ill. We cry at movies, or fall asleep, then forget them. Finn had arrived, in impossible fulfillment of every wish that lay buried in the ground I tread on my way to school. The loves of our youth build themselves into elaborate knights in shining armor until their images eclipse life itself. Sometimes they become reality, but then, even if they aren't the clichéd disappointment, they still fail for the same old reasons. One person moves away, or the other gets bored, or they run out of things to talk about. Our desires start young, are unreasonable, and can't be trusted. But there's always another box of Junior Mints.

OOOOOOOOO

Part Two

SUGAR AND SPICE

OOOOOOOOO

Smarties

In my youth and adolescence, candy was an overindulgence—a mild drug with which I experimented and to which I became addicted. At times it was a substitute for the sweetness and contentedness that I found elusive. It was also a substitute for natural sugars. By the time I got to college, I still wouldn't eat even the most basic fruits. It was usually the texture that daunted me: oranges were thready and indigestible; apples were too hard for my orthodontia-weakened teeth; bananas had soft spots and strange black bits in the center; peaches were furry; strawberries grainy; others inconceivable. I had never had a grape, I boasted, but I loved the taste of purple.

On my way to class every day I stopped by the Wawa to buy breakfast. I bought myself a half-pint of orange juice, a bagel

with cream cheese, and several Smarties à la carte. The idea was that the Smarties were for later. (This is a generic phrase that is used whenever candy is bought in conjunction with normal meal food. "The raw cookie dough is for later. The ice cream is for dessert. The chocolates are for him, not me." It is always a lie.) When I got to class the orange juice and bagel would disappear, and then, without pause, I would start in on the Smarties, stacking the empties on the edge of the desk. The early morning energy of a fresh roll of Smarties made them a great stand-in for fruit.

Smarties (the American variety, not the homonymic British sort, which resemble M&M's) needed to be eaten in pairs, but the colors, and their mild accompanying flavors, weren't to be mixed. I would unfurl a roll and sort the Smarties by tint on my desk. Saving the purples for last, I would eat two at a time, making my way through each color. A single bite was all it took for the Smartie to dissolve. It happened quickly. A pack was gone in under a minute, and the next pack was opened immediately.

There was a moment, in the course of any Smarties experience, where I had to think of Johnson's baby chewable aspirins, which have a chalky mild orange flavor. Consider: not only are orange Smarties orange-flavored, but according to the company, the white Smarties are "orange cream." Two orange-flavored colors! Outrageous. I always let the aspirin association enter my mind and then, with meditative skill, I *let it go*. I focused instead on the taste of the green Smartie. Was it really strawberry? The mind boggled, but there was no time to waste. Smartie consumption

was nonstop. Any attempt to slow it down created an unpleasant sense of deprivation. Once the process began, it was not to be interrupted.

Every so often I would look around the class and notice that, although it was 10:30 in the morning, and although there were almost 200 students in the class, I was the only one eating breakfast, much less a breakfast-dessert of Smarties. It occurred to me more than once that eating in class might be considered inappropriate, but I reassured myself that most of my classmates got to eat in the college dining halls and had probably had three-egg omelets for breakfast, while I lived off-campus and was responsible for my own meal plan. Perhaps "responsible" wasn't the best word.

I knew how I was supposed to feel about my bright college years, but knowing didn't help. In the back of my mind I wanted to learn something or other, but I desired intellectual growth only in the abstract. The actual acquisition of knowledge was, at that time, unpleasant. I was taking a class called something like "Cultural Criticism: Social, Political and Literary Criticism in Contemporary Culture." This particular class boasted three cutting-edge professors, each from a different department, battling out their various perspectives of cultural analysis for our benefit. Eating in class, with the stack of Smarties wrappers accumulating, I found reason to let the professors' words drizzle straight through my brain, not repelled, but unabsorbed, insignificant.

○

Rather than engage in academic expansion, I used the morning class to inflate my limited romantic conquests into tales of true love. Much as I practiced on Smarties for future fruit consumption, my love life was sweetened by artificial flavors. Tobias was a swimmer with a hypnotic voice. He talked as if he had overcome a stammer. When I met him for the first time, he handed me a matchbook with a poem in it. That was enough for me. I was new and eager. He called and whispered and appeared in my hallway. But I was too shy to talk. I always thought my real chance would come at an undefined later moment. Now that I had been noticed, next I would be discovered and loved. For months I convinced myself that something was going on, fabricating substance from sweet nothings, when in truth not much really happened. We never ate dinner together, not even in the dining hall. We never had a sustained conversation. I couldn't speak or make eye contact and would yearn for him to approach me in the mailroom or as we passed each other between classes. Sometimes he noticed me and sometimes, when he must have, he didn't.

Finally, when spring was almost visible, I ran into Tobias late, at a keg party. Friends had brought me there, and I had no idea where we were. The keg was romantically situated on a balcony sewn in by trees. The tiny nest floated there, unattached to the rest of the night. As I realized that Tobias was standing next to the keg, rain started to fall heavily on the roof of the balcony. The surrounding leaves were instantly soaked, clumping and weeping, but Tobias and I

and our keg centerpiece stayed dry in our treetop hideout. The rain was so loud that we couldn't hear each other, and all we could do was, finally, kiss. People herded past, refilling cups and departing, but all that mattered was that I was certain that we had broken our own curse and that we were mutually celebrating its lifting.

We ran through the rain to Tobias's apartment. There were candles, music, and a noiseless, urgent progression from the couch to the bedroom. His eyes were so close to mine that he had to be about to love me. We were restless, finding new ways to be next to each other. I had never slept in a man's bed, and every movement he made was like a hand shaping clay. Poor Pygmalion, he had no idea.

Morning broke, and I watched the rise of his breath. I memorized the shape of his body and the flaws in his skin. The blue flannel sheet seemed enchanted. The walls around were lined with books and tokens, small mysteries that I was sure to unravel over time. This room would become familiar. There were distances all over the room, between me and the door, and me and the window, my arm and his arm, my feet and his shelf. I counted the places our bodies were touching. Those distances would open and close. The air between us would change shape and learn the way we moved.

But, as happens, when Tobias awoke, the room filled with him and froze. A narrow path emerged for our departure as he walked me back to my apartment. I had us sharing pan-

cakes; it was barely dawn and we were silent again. This was the beginning and the end, and it happened again with Tobias, and a couple others before I learned. From then on I woke in the morning with my own hard edges, but mine were reactionary, protective. An evening still changed me, but that was for me to mull over in the introspective greenhouse of my 10:30 class.

There are things worth waiting for, my mother told me, and I saved myself for fruit.

Swiss Petite Fruit

Later, as fate had it, I moved to that same apartment with the little rainy balcony. My roommates and I rarely went out there, although we did use it to host a keg at one forgettable party. In fact, we rarely spent time in our apartment at all. It was a way station dominated by a long hallway. The refrigerator had scary Saran-hooded bowls from sporadic forays into cooking. Some potatoes were sprouting on the windowsill, and my roommate Kate thought they were interesting, so she refused to throw them away.

Neal became my first real boyfriend. He wooed me over chess. Our first lesson lasted nine hours and ended chastely in my bed. On our second lesson it became clear that I wasn't going to be a grandmaster anytime soon. Our third lesson was not so chaste. It was winter; we were in the midst

of exams. I was supposed to be studying a wall of art history images. Instead I sat in the library watching it snow, and all I wanted to do was go for a walk in it with Neal. He was awkward and romantic. I was dizzy and enthralled. He had shaggy blond hair and one bad tooth. He could play the guitar behind his back, and with his teeth, and he took his academic work very seriously. Neal told me it wasn't that I needed to absorb more facts, but that I had to learn new ways of thinking. I stopped going to midweek parties and tried to access my inner intellectual.

Neal lived off-campus, over a candy store called Sugar Magnolia. He and his roommate, Pete, had developed an impressive domestic routine. They cooked together most nights, then retired to their rooms to study. The dishes got done right after dinner. Neal slept on a skinny monk's bed. It was narrower than even a single bed, and we were comfortable there.

We slept embracing each other, and the first time he turned away from me, I cried.

"Face me," I said, poking his shoulder.

"You're breathing on me," he said.

That spring, his work was noticeably more important to him than I was, but still I would walk down Chapel Street on my way to his apartment feeling light-hearted. I wore Salvation Army motorcycle boots that my mother couldn't abide, jeans, and long-sleeved T-shirts. When it was chilly, I had a fringed suede jacket that I had found at a thrift store. I had

never exercised and saw no reason to start. My classes ended by four, and the late afternoon sun promised a long, lazy evening. I knew enough to understand that having nothing to do but read Shakespeare or some other pre-eighteenth-century poet was a luxury that wouldn't last forever. On my way up to Neal's apartment I always stopped into Sugar Magnolia. I liked the nutritious-sounding Swiss petite fruit. They were ridiculously expensive at eight dollars a pound, so I would supplement the quantity with some caramels for filler. Then, up until dinner, Neal and I would study together. He would be at his desk, tilting his chair back with gangly limbs akimbo, and I would curl on his plank of a bed, eating petite fruit and reading *The Mysteries of Udolpho.*

Those Sugar Magnolia days overlapped and repeated themselves. They were lazy and simple, and even if I didn't have as much of Neal's attention as I wanted, I was finally in a genuine relationship, and I could find comfort there. This is the most satisfying way to eat candy: with a good-size bag—it must be big enough so that you are through with the candy before the candy is through—with a page-turner (the Sunday *New York Times* will do as well), and a boy keeping your feet warm. It is all you need on earth.

Conversation Hearts,
the Reclamation

A person can only take so many conversation hearts. After the third full bag of the season (I prefer the larger hearts to the standard-size Necco brand), they start to taste sickeningly chalky. But they have charm. Their palette is as tied to spring as candy corn's is to autumn. They are hopeful and convincing. When you are alone, you can use them like a Magic Eight Ball, thinking, If the next one says "true love," I'm set for the year. I am not alone in my consumption of conversation hearts. They've been around (originally as Motto Hearts) since 1866. According to Necco (the New England Confectionery Company), in the Valentine's season they manufacture more than eight billion hearts, which sell out in the space of six weeks. Once, walking in Cambridge, I stopped in the middle of the street.

"Necco is nearby," I announced, sniffing the air. Tracing the scent, my friend and I turned the corner, and there was the factory. Every year I consumed more than my share of the eight billion, but this year I wanted a change.

No boy had ever given me conversation hearts, or anything else for that matter, for Valentine's Day. Ever since the eighth-grade ski trip, conversation hearts were a reminder of the absence of romance, the admirers who never emerged, the flirty conversations that never happened. Now I finally had Neal, a flesh-and-blood boyfriend, and I wanted my Valentine's Day, dammit. Nothing would better put a nail in the coffin of my past loneliness than a boyfriend-sponsored sugar-coated holiday. When February rolled around, I thought I would spare us both my disappointment.

"I know you don't believe in Valentine's Day," I started off.

"I'm Jewish," he said. "We don't observe it."

"Well, all I'm going to say is I know you think it's a Hallmark holiday and all, but can't you just use it as a great excuse to show me you care about me?" I was way out on a limb. Neal's emotional repertoire did not include gestures of affection. "Actually," I told him, "Let me put it this way. Do something for me on Valentine's Day. Candy. Flowers. Lingerie. Candy. Anything. It can be a cliché. I don't have to like it. You don't have to enjoy it. It will just make everything a whole lot easier for both of us."

Neal rolled his eyes. I could tell he thought I was a victim of society.

Meanwhile, I wanted Neal to be given things, by me, by anyone, because I thought he deserved more love and affection than he had gotten as a kid. I bought white paper and folded it into a card. On the front I wrote in teacherly cursive, "This is not a valentine." Above the words I pasted a tiny fluorescent pink heart. The little heart opened to say, "Be mine anyway." I left the inside completely blank.

Neal and I rented a movie and ordered in food. He gave me a box of chocolates, dutifully. I gave him the not-valentine.

"You weren't supposed to do this," he said.

"I know, but it's not a valentine, see?" I was proud of my surreal workaround. Neal acquiesced. It was okay, then, my secret planning of the perfect valentine that evaded his anti-Hallmark notions. I felt nominal justice for my former love-starved self, eating the requisite chocolates from their requisite heart-shaped box. And the valentine that I made for him stayed on his desk, where weeks of junk mail piled up and overflowed. It stayed there—not thrown away, but not saved. It stayed there, invisible to Neal, and every time I saw it, I felt a piece of myself flutter out into the air, up and up, and away and lost.

Lipo

Neal and I didn't arrange to be together when college ended. We didn't break up or make any decisions, we just made our separate plans. I moved to Prague to teach English. I sat in a bar with a friend named Ben in early fall. He looked at my expat cheer and said, "Brace yourself for winter." Ben was right. It was a grim winter. I lived out in the suburbs, in an area of Socialist housing where one tall cement building after another stretched as far as the eye could see. The walk home from the subway was bleak. Most of it formed a wind tunnel that left me breathless as I struggled to pull open the door to Dům Učitelů (my building was called Teachers' House). As it happened, I didn't like teaching English. At night I struggled over the next day's lesson plans, nauseated by the thought of standing in front of teenage kids, pretending to know what I was doing. I took a hippie approach, bringing in silly songs like "Free to Be You

and Me" and sending the kids out into the center of town to collect data from English-speaking tourists. Even so, the responsibility of teaching tortured me.

In a candy store in the old town square I discovered Lipo. The name, contrary to logical inference, had nothing to do with the treatment that eating it made necessary for your thighs. It actually stood for LIberecké POzivatiny, which pretty much means "food/confectionery from the town of Liberec." Lipo looked like engorged Smarties, rounder and a bit softer, essentially yet another mutation of sugar pellets. What initially attracted me to Lipo was the packaging. On the front of the little plastic bag was a drawing of an orange dog. It was a rear view, and the dog was looking coyly over his shoulder, back at the candy-eater. The dog's tail was raised high, and, unbelievably, there was a dot immediately beneath it—the dog's slightly exaggerated anus. The evident implication was that the candy was dog shit. I loved to think of the worker who was given the task of designing the packaging for Lipo and ascribed this fate to the innocent candy. It was a simple and elegant demonstration of socialism at work. In admiration, I bought at least five packs of Lipo every day.

I had to buy five. When I moved to Prague, it was not my goal to learn the language. Czech was not only difficult; it was exclusively spoken in a single, small republic. I saw no need to learn any more than was necessary to get by. I learned the basics, however, like how to ask for Lipo in stores. I wanted four packs. But the Czech word for four

was *čtyři.* And it was even harder to say than it was to spell. Five was *pět.* So five packs it was.

I was often sick in Prague. Maybe it was the candy. I was old enough to have outgrown the thoughtless binge candy eating of my youth. Now, when I binged, I thought about it. I also tried to exhibit more control. It was embarrassing to eat the way I had. As my candy consumption fluctuated, my relationship with candy became more conflicted. I loved it — at least for the first few bites — but then I couldn't stop. It was bad for me, but I wasn't overweight, just unhappy with my body in the same old way that all of my friends seemed to be. Sometimes when I ate candy it was delightful; sometimes it was just depressing.

Candy could be a downer, but that wasn't my only problem. I could not bring myself to stomach teaching. Almost every day I lacked energy, enthusiasm, or even the ability to fake either one. It wasn't that I was homesick; I had no idea what was wrong. I went out to a bar with some of my older students, and one of them looked up a word in her Czech-English dictionary. "You're 'self-conscious,'" she announced. I felt ashamed and lost. I wanted to quit, but I had never changed my course before. School, summer jobs, college — I had always done what was expected of me. But those months of ingesting the subversive Lipo fueled me with a will to control my own destiny. Finally, near the end of the second term, I lied to my school and told them that a relative was ill and that I had to return home. Maybe they believed me, maybe they didn't. I felt terrible doing it, but I wasn't myself. Maybe I missed Neal. Maybe I had taken the

wrong job. Maybe I was just enduring post-collegiate strife.

I didn't realize how unhappy I had been until I came home to New York City. Then I remembered what it felt like to wake up, stretch, and look forward to the day ahead. Neal and I, through letters, had decided to move in together. The return to my mother's apartment to job-hunt and find an apartment with Neal was more of a relief than I could have imagined. I knew then that it was worth the lie to the school where I had taught. There was a lightness in daily life that I had forgotten entirely.

Frosting

Not long after returning from Prague, I was at a wedding where the cake had the very best variety of frosting. A luxurious white fondant, creamy and sweet, with the faintest shell on the outside. The woman next to me ate her cake right up to the edge of her frosting but left it all there, intact. I stared at it for a while. I tried to let it go. Finally I couldn't help myself. "Can I have your frosting?" I asked like a three-year-old.

"Sure," she said. "You like that? It's too sweet for me. I like savory."

Savory. Ah, yes. I've heard this one before. Choose your team: sweet or savory. And if it's savory, we're wasting our time. If you're savory you'll never understand. Please exit through the door on your left.

Now, ice cream is universal. It has a solid reputation as a decadent dessert. It's sweet and fattening, but popular.

Candy consumption may be a bit more covert, but it's out there, in every store and movie theater. Happens all the time. Perhaps my candy consumption is extreme, but it transpires in a relatively socially acceptable manner. I am not visibly aberrant. But frosting is a different matter.

The desirability of frosting may be the ideal litmus test for the true sugar addict. What I want to consume is very different from what I actually eat. Believe me, if I did not exert enormous self-restraint on a daily basis, things would go differently in the baking aisle of the grocery store. Oh, the store-bought frosting that I would buy. Oh, how I would eat it at every opportunity. I can see myself now, lifting delicate spoonfuls out of those round plastic tubs. Vanilla. Lemon. Cream cheese.

How will I ever know what a life of uninhibited consumption would be like? What if, instead of exercising willpower every single time I enter a grocery store, I just went for it? I never do. Instead, I fill my cart with vegetables that may or may not get consumed, cereal, yogurt, cheese, and often a single indulgence (such as the aforementioned ice cream).

Frosting represents all the temptation I've left to languish on the shelf, day after day, week after week, year after year. If only my body knew about everything I didn't eat. If only I could get credit for it. Where is the reward for all that frosting, inevitably wasted on cakes instead of properly enjoyed from spoon to mouth? What do I get for resisting the bags of butterscotch or white chocolate chips? The brownie mix, the tubes of decorative icing? And in other aisles, the miles of never-purchased cookies, the enormous

Cadbury bars, and the lifetime supplies of caramel topping? I want all of it, always. I never buy any of it. And what's my reward? Alas. Nothing.

Willpower is not black and white. I exercise willpower on every trip to the grocery store, but no checkout person watching my selections bump down the conveyor belt would believe it. What I hope for, one day, is to be free of the need for willpower. I didn't need willpower to avoid heroin. I had no natural desire for it. I didn't need willpower to avoid meat. I ate it when I wanted, in whatever quantity I desired. Willpower is a denial of desire. It can be partial ("I'm not having dessert today") or absolute ("I'm not having dessert ever"), but it is always self-denial. I don't want to curb desire. I want either to indulge it or to eradicate it.

I wish I'd indulged the frosting fantasy as a girl. Rather, I've only purchased pre-made frosting twice, ever. A remarkable show of control, but it would be wrong to go to my grave like this. On the other hand, I would like to live to a ripe old age, which probably means that this foolish self-torture must go on. There is only one clear solution. I'm going to establish an assisted-living residence called Home Sweet Home, where we'll ice our frosting and top our toppings. Children will look longingly through the windows as we play Jelly Belly bingo. We'll provide custom candy bouquets to our residents. We hope you'll join us for the nightly ice-cream social. And the onsite dentist will provide daily plaque removal. We are the music makers, and we are the dreamers of dreams. Willy Wonka, eat your heart out.

The Assortment,
Revisited

Neal and I set up a bite-size apartment in Manhattan's Murray Hill. It was a miracle that the bed fit in the bedroom. He taught guitar, and I found a job as an entry-level assistant. We earned just enough to pay rent. We had been there for almost a year when Lucy called me. We hadn't talked often since high school, but she was phoning to tell me that one of her closest friends, a woman who had gone to school with us, was missing. It was Laura, at whose basement birthday party I had first become self-conscious about my unwavering focus on candy.

The candy tones of that night are forever singed in my memory. I was an insecure seventh grader. My teeth were crooked, but not yet mature enough for braces. My hair was

better than it would ever be, enjoying a final year of being long and wavy before it went to frizz, but I didn't know that. What I knew was bad enough: I had a squawky voice and bug eyes. I was not tall, blond, or properly attired. Knickers were riding an appropriately brief wave of popularity, but my mother had refused to buy me a pair. After opening presents that night, we went to a knickers-dominated dance where I didn't dance, only stood stiffly in the corner holding one wrist with the other hand so as to have something to do with my hands. There were rumors that the seventh-grade boys had beer in the courtyard; only the girls who apparently had something to say to boys went out to investigate. I lay low, harboring no hopes of actually having fun. I preferred to set achievable goals: my aim was to be *perceived* as a person who was having fun. Our birthday party crowd stuck together until it was time to head back to Laura's basement in Bethesda. There we sucked in helium and sang in high voices. We stayed up late, trading bracelets and loyalties. Balancing with invisible desperation on whatever footholds I thought I had achieved, I was afraid that the winds of friendship would shift at any moment and I would plummet, rejected and alone. But through the insecurity I also almost believed that it would all pass, that I would blossom into a beautiful, smart, popular girl, that we all would, and that this night would be buried among many fun, miserable pre-teen parties.

A few days after telling me of Laura's disappearance, Lucy called again. In that same house in suburban Maryland, she told me, a horrifying event had taken place. Upstairs from

where our circle of sleeping bags had been, Laura, the birth-day girl, who had just graduated from Harvard, was mur-dered while she slept in her childhood bed.

In my head the two events continue to happen, at the same time. From my perspective on the middle floor of the split-level house, I see down into the rec room, where we are seventh graders, giggling and passing around a box of as-sorted candy. At the same time I see up into Laura's bedroom, the dark shape of an intruder heading in toward her. The in-nocent memory battles the dark, sad outcome, as if both truths can't exist, and it feels like the darkness had to be there at the time, that we knew in some way that our innocence would be ruined. While we sampled candy stew, and listened to horrid LPs, we had a sense, not in our minds but in our souls, that life would not be simple, that tragedies of varying degrees would befall us as individuals and as a group. Par-ents would divorce, planes would crash, hearts would break, our health and happiness would fall away in pieces. And much as we tried, we could not bring enough sweetness into our world to prevent the worst from happening.

White Chocolate
Breakup

My relationship with Neal, having endured my Eastern European hiatus, was petering out, but we didn't know it yet. I took my job very seriously, and my boss, Sam, took the term "full-time" literally. When I wasn't on the phone with Sam, who worked from exotic vacation spots around the country, I went to industry events. I was reserved at work, but I had a strange, increasing feeling that I wanted to meet people and understand what they did. I later identified this feeling as the first glimmerings of ambition.

Neal was a hard-core musician: he claimed that his skill level was such that if he did not practice for at least six hours every day, his ability would decline. He stayed home, teaching lessons, fending off the landlady's noise complaints, and

cooking himself discount chicken. We were probably too young for cohabitation. We were more like roommates. We didn't own a vacuum cleaner. While we spoke to each other on the phone most days, I don't remember ever coordinating grocery shopping or evening activities. After we broke up, Neal would tell me that we had had a serious cockroach problem that he successfully hid from me.

Pete was Neal's former roommate. It wasn't strange that I went to visit Pete and his family in Wisconsin for a week without Neal. In fact, Neal and I had never taken a vacation together. What money he did earn he spent on musical equipment and on his half of the rent. Besides, travel cut into practice time. By the time I went to Wisconsin, I had been dating Neal for so long that it seemed perfectly normal to me that we never took trips, much less went out to dinner or to the movies. I did those things with my friends instead.

Pete's place in Door County was on a flat, clear lake. Every day we ran down to the water and Pete plunged straight into it, yelling, "I'm the fastest swimmer in the lake." He was the only swimmer in the lake. On the second night Pete took me to the Confectionery. It was a candy Shangri-la—an enormous, octagonal store with every imaginable species of candy. I focused on white chocolate breakup: When you took a bite, the flavor wasn't immediately apparent. It emerged slowly, sweeter than brown chocolate and not as rich. Of course, white chocolate isn't officially chocolate, since it is made with cocoa butter, not cocoa beans. But who am I to quibble? The full, wholesome flavor went well with

the clear Wisconsin air. It felt healthy and revitalizing. I also stocked up on Pixy Stix and other miscellany. But by the next day my whole stash was gone. Pete's car was a stick shift, which I couldn't drive. I wasn't about to demand that we make a daily trip to the Confectionery. It didn't seem right. But everytime we went to a bar, or out to dinner, Pete knew enough to swing by.

The night before my birthday, another friend of ours was meant to arrive. After dinner, Pete and I set up a cribbage board at the picnic table near the driveway and decided to play until her car rounded the corner. The evening was so quiet and still that we couldn't feel the temperature of the air around us. There were no bugs out, only the faint sound of crickets. All this in combination with a well-positioned outdoor light made the picnic table feel like a stage set. I ate white chocolate, Pete drank beer, and we dealt game after game. Our friend was late. We kept on. The phone rang. She was an hour away. Finally, close to midnight, the high beams of our friend's parents' station wagon announced her arrival.

"This calls for a midnight swim," Pete announced. We ran down to the lake, stripped, and jumped into the water. I grabbed an inner tube and climbed into it. As I floated there, I looked up at the sky. It was mid-August and the Perseid meteor shower was on fine display. I floated until my fingers were raisins.

The next night, I called Neal.

"Today is my birthday," I told him.

"Right," he said. "Happy birthday."

Devil's Candy

You try to end things with candy. You tell candy it is over, that candy is too much to handle, that you love candy, but you just can't go on like this. You want candy out of your life, for good. But candy keeps coming back. Candy knows when you are weak, tracks you down at parties, at work, in moments of boredom or celebration. Candy promises to be good, not to come on too strong, to give you some privacy. But sooner or later candy is back to its old ways, and you feel foolish, but you love candy and can't seem to let it go.

Fruit

There was no fanfare when Neal and I broke up. I came home one day and he said, "I don't think we should live together next year."

"Okay," I said. "I have to be someplace in half an hour." After four years, our relationship had run its course. As when I eat a large bag of Hugs, I had gone way past my breaking point without realizing until the bag was empty. Neal argued half-heartedly that moving out didn't mean we had to break up, but I insisted that it did. I found a roommate in Chelsea. He moved to Brooklyn. We became people who had lunch together. I started seeing the guy I'd kissed once while we were taking "time off." Neal slept with a woman who didn't inspire jealousy. At a crappy diner on Union Square I said, "I just want to tell you that I'm glad we spent those years together. It was worth it. I like you and it's good that we're friends."

He said," Man, I can't believe you're making me have a relationship talk."

While I was moving on, I figured it was about time I got around to liking fruit. Rumor had it that fruit wasn't so bad. It was certainly the prettiest food, and it had a reputation for being sweet. The concept of "nature's candy," was alluring. Scientists say that we crave sweetness because our ancestors often had to deal with caloric shortages. They evolved to desire, consume, and store as many calories as were available. When I learned this, I realized just how highly evolved I was. I had gone beyond primate fruit craving to crave man-made, tastier products. One of the results of this evolution was that my brain, like everyone else's, released endorphins when I ate a lot of sugar. Endorphins made me feel good. Ignoring the inevitable crash, sugar was nature's happy pill. But much as I took pride in my sugar consumption, it did occur to me that the greatest sign of evolution was the ability to make intelligent decisions despite physical desires. I wanted my cravings to be under control. Maybe those endorphins were my nicotine, and maybe eating fruit would be the Patch!

My breakup gave me a new lease on life. Besides, I had a responsibility to society. Most people tasted fruit when they were so young that it was a forgotten breakthrough. Fruit was something they'd always eaten. As a rare breed—the late-blooming adult fruit taster—I could savor each experience. I had never tasted even the most basic of fruits. I hadn't had a grape, a pear, an orange, a cherry, an apple, a raspberry, a strawberry, watermelon, and so on. My parents

had tried futilely; the closest things to fresh fruit they had gotten me to consume were orange juice, canned pears, and applesauce. Thus I had my first grape at the winery where it was grown. My first cherry was on a picnic in Tuscany. A friend gave me my first wedge of orange on a hot, hot day at a deserted quarry. I had my virgin pear at a party I threw for a friend from out of town. She picked it out at the store. One day on the beach I sampled a melon and a kiwi, cut with a plastic knife.

The only fruit that I loved at first bite was raspberries. Otherwise, the tastes had an odd, sour familiarity. I came at them backward, having spent years tasting the candy versions. Just because I'd opened my mind and mouth to it, fruit didn't settle right into my diet. It was still overwhelming. I couldn't manage whole fruits at first. Small bites, delicate servings, and little by little I was a fruit-eater. The hardest hurdle was the grocery store. Being willing to eat fruit didn't mean I understood how to buy it. When was it ready? When did it go bad? I didn't mean to be wasteful. Yet time and time again I would purchase fruit, only to watch it with trepidation as it rotted on the counter. Why eat fruit when there, two aisles over, were bursts of refreshing fruit flavors for me, but sweeter times ten? Could reality really be so cruel?

I gave fruit a try. I just wasn't very good at it.

Lemonheads

No cavities. Susan, my dental hygienist, congratulated me on my teeth. My gums were healthy; not too much tartar; no cavities this time.

"Why don't I get cavities?" I asked her.

"Why should you?"

"You're not going to like this, but I eat a lot of candy."

Susan smiled at me. "I love candy," she said. "When I was a girl I used to hide Lemonheads between my mattress and box spring. Every morning, when my mother called me down to breakfast, I'd shove a handful in my mouth." She opened her mouth. She had fillings from front to back.

"So how come I don't have fillings?" The truth was that I had three, in my back molars.

"Your enamel is strong, or your mouth does a good job of cleaning away bacteria. Some people are just lucky," she said.

"I had really bad acne," I told her. "Believe me, I get my share."

Fireballs

After Neal, a few contenders and cads came and went. Then I was fixed up with Dylan. In the spirit of the tech boom, we were set up by email. He was a lawyer appealing murder convictions on the West Coast. Our correspondence, tentative at first, quickly swelled to meaningful proportions. Every day I hurried to work in eagerness to see his name in my inbox. I didn't drink coffee. Instead, I had Dylan's increasingly flirtatious correspondence. His favorite candy was the fireball. He wrote:

> The candy itself requires little introduction, or praise, to cast into the pantheon of great sweets. It begins with a gentle ruse: *Yes, I am a candy, I taste good, don't worry about the whole "fireball" moniker, no fire here.* No matter how many you've had in the past, for the first thirty seconds you think, Not bad, I

can handle this. Then slowly the spice kicks in, and whether you are watching a movie or driving or swimming in a cold Maine saltwater pool, there is nothing that can save you. The spice has laid itself into your gums, into your tongue, into your sinuses, and you're a goner. But what makes the fireball a perfect candy, instead of simply a mean, nasty, artful candy, is that in the end it says, *Hey, just kidding. I'm really a candy.* The sweet white center emerges, and you forget all about the spice, and wonder what possibly could have been the big deal. I've eaten a lot of candy in my time, dear H, but in the end, you would have a hard time convincing me that there's ever been a greater expression of candy genius than the deceptively simple, elegant fireball.

No question. I had a crush on Dylan. How could I not? Our correspondence was a little like a fireball—growing increasingly intense, although it never got too spicy to bear. We were cautious and overly aware of the deceptive nature of email. The images we projected were selective and our readings of each other were unreliable. We stayed away from presumptions about what might exist between us and instead entertained each other with stories.

But we couldn't help imagining, and finally he decided a trip to New York was in order. In the week before he came to town I looked at every man who passed me on the street and imposed his looks on Dylan's email personality. Would I like him if he looked like the doughy man on the bicycle, or the

scrawny waiter at the diner? Would I like him if he were him, or him, or (heaven forbid) him? By the time the day of his visit arrived, I needed him to like me, because if he didn't like me after all that correspondence, then it had to be my looks. We went out to dinner. We talked easily and with the familiarity of old friends. He was fine: on the short side with blond hair in a ponytail. But in actual daylight the cinnamon intensity of our fast and furious emails faded into a sweet, sustained after-flavor. It was not traumatic and did not feel like a loss. I didn't know exactly why (maybe because he was a candy-sucker, not a biter), but we were meant to be friends, and only friends. It was simple, it was elegant, and it was destined to last far longer than a single fireball.

PLANET EARTH

- crust
- upper mantle
- lower mantle
- Gutenberg discontinuity
- Outer core
- Inner core
 (Temp: 8,500°f)

equatorial diameter
7,900 miles

ATOMIC Fire Ball

- fiery red crust
- not too hot mantle
- suck-or-toss threshold
- Hot outer core
 (Temp: 8,500°f)
- mild inner core

equatorial diameter
20 millimeters

Feeding the Habit

Of course I wanted to lose weight. I'd wanted to lose weight for as long as I could remember. I wanted to lose weight like I want to find a twenty-dollar bill on the street. Who wouldn't? It was an idle concept. I never did anything about it for years. Then, as my twenties passed, a sad new truth dawned on me. I would have to exercise. I would have to do it not to lose weight, but to avoid gaining weight every year while indulging my sugar habit. Going to the gym would buy me candy calories.

My gym had a TV at every cardio machine. I guess they were merely demonstrating the sponsorship potential, because their ads didn't promote any particular product. Instead, the ads showed something really tasty—a cupcake or a chocolate bar or a doughnut, shiny and fresh. Then the calorie count would flash on the screen. The next shot would say how many hours of hell you would have to endure in the

gym to burn off all those calories, and then the taunting slo-
gan would appear, "Doesn't it taste good?" It played over
and over: doughnut, calories, hours, "Doesn't it taste good?"
I chugged forward like a hamster on the elliptical crosstrainer,
wondering if the ad was my mantra or my curse.

Going to the gym and eating candy. It's all about math.
You eat. You burn. You eat. You burn. If you're lucky, you
sculpt attractive muscles, and these muscles require extra
blood or something, so you burn bonus calories when you're
not even trying. I didn't want to count calories—math was
never my strongest subject—so I figured I'd just go to the
gym like everyone else and log some negative calories.

Needless to say, I was in denial about a critical compo-
nent of the equation. Even if I was going to the gym like lots
of other working girls, I wasn't quite eating like them. In
1998 candy consumption in the U.S. was at a per capita
average of 25.20 pounds, but I don't think those people at
the gym were doing their share of the consumption. They
were doing a lot of salad munching, I could tell. As for me, I
was more than making up for their below-average perform-
ance. I figure that my candy serving size is about a quarter
pound. It would take me only 100 servings to get to 25
pounds a year, which would mean I was eating candy only
every third day. Three-quarters of a pound per week, now
that's more like it. Let's see, that's . . . 39 pounds per year.
Certainly this is on the high end. However, Denmark, a
clean, well-respected country with lots of castles and other
attractions, consumes a per capita average of 36.85 pounds
per year.* I'm normal in Denmark! I need to live there!
With my people!

I keep going to the gym, dreaming of Denmark. I never lose a single pound, but working out makes candy consumption feel less like a downhill slide to obesity. Instead, I climb stairs, climb endlessly upward toward that doughnut, inspired and hopeful.

*Source for statistics on previous page: candyusa.org, citing *CAOBISCO IOCCC Statistical Bulletin*, Brussels, summer 1999. U.S.A. figures are based on the Commerce Dept. MA20D figures.

107

Bull's-Eyes

When I started talking to Lydia about candy over lunch one day she looked bewildered. It didn't seem like she had ever given it much thought. Did it really deserve our attention? Then she got a distant look on her face.

"You know," she said, "I used to love bull's-eyes." Bull's-eyes, aka caramel creams, are caramels with white cream in the middle. For some reason the cream is always cool, like the mint of a Peppermint Pattie.

Caramel creams were invented in the early 1900s by R. Melvin Goetze, Sr., the son of the guy who founded The Baltimore Chewing Gum Company. Now that's my kind of family!

I looked at Lydia. Always stylish, she was wearing camel suede pants and a crisp white shirt. Her skin had a honey glow, and her hair was a nearly platinum blond.

And they say that people look like their dogs.

Old-Fashioned Marshmallow Eggs

The old-fashioned marshmallow egg is rare. But rare as it is, rarer still is the old-fashioned marshmallow egg lover. The only other fan I have ever met is my mother.

Perhaps you will recall: at Easter there used to emerge a particular variety of marshmallow egg. It was a bit shorter than my thumb. There was a candy coating that was more opaque than the outside of a jellybean, and inside was the marshmallow filling—a dense white sugary nougat, not as sticky as Peeps, with no gummy pull to it, but closer to that than anything else. These eggs often came individually wrapped within a larger plastic bag for egg hunt purposes. They were incredibly sweet, and entirely addictive. The outside shell of

each egg gave it a distinctive flavor. Purples, whites, and pinks were the best. Green, which in candy's attempt to replicate lime often tastes like cleanser, again did so here. Far superior to Peeps, which have had a surprising surge of popularity, these eggs are now made by Sweet's Quality Candies of Salt Lake City. They admit to having few accounts in the East. Perhaps it's for the best. How different my life would be if they were readily available.

Luke became my boyfriend reluctantly. We had been friends for years. Then one day, on my incorrigibly romantic rooftop, we got involved. Not long into our unofficial relationship, I opened an email from him innocently, suspecting nothing. He had seen this movie; he had gone to a park; he had talked to his best friend in Seattle. Oh yes, and on Monday he had gone out with Catherine. They had fooled around. In fact, Luke called to my attention, he seemed to recall being with Catherine last week as well. My stomach rolled over and I thought there was some kind of white heat in or outside of my head. I was at work in an office outside the city. I went to the bathroom and refilled my glass of water, then wrote back to Luke in a flash, not angry, not accusatory, but certain.

"What you did doesn't break the boundaries of our relationship, but I feel sick and we'll have to stop our dalliance now," I told him. Send Mail.

He wrote back quickly, sounding worried that I was upset but determined to stay friends.

"We'll be okay," I wrote back curtly.

○

The next night we met in a bar. We had known each other for a long time. When I found him, his freckles and round eyes were so familiar that I felt perfectly friendly toward him. He was wearing the orange sweater that I'd given him. I could easily imagine that nothing disturbing had happened.

"I know I was clear with you about what's going on with me. . . . I'm not ready for another serious relationship," he told me.

"Yes, I know," I admitted. "You're an ethical slut."

"But we've been spending a fair amount of time together, and I like it. Most of all I don't want to lose you as a friend. I would rather keep our friendship than risk it by being in a relationship."

"Right," I said, "but it's too late for that."

"I don't really feel that way," he said, "but I realized that I like being with you and your friends as more than your friend."

"Well," I said, "it's not like we have to decide anything right now."

Luke agreed. Another fifteen minutes passed; then he said, "So I think this is going well, don't you?"

"I'm still miserable," I said. He wanted to know why. "Because you haven't made up your mind. We are so easy together. I can't imagine why you wouldn't want to keep being this happy."

Luke took a sip of beer and began to speak. Did he say he couldn't bear to lose me? No. Did he say that he was in

love with me? No. But he did say, "I have made up my mind.
I want to try being in a relationship with you."

I did a double-take. "Um, don't you want to take some
time to think about that?"

"No," he said. "No, I've thought about it."

"You just want to get laid tonight," I said.

"It would be nice."

It wasn't the healthiest launch, but I was used to finding fla-
vor and satisfaction in less-than-nutritious morsels. A few
months passed, and we found ourselves on steadier ground.
My father was getting married, and Luke was my date. For
the Sunday after the wedding, I invited my grandparents
and some other relatives to tea at my apartment. While I was
at the wedding brunch, Luke prepared my apartment for the
tea. He sliced fruit and made a platter. He set the table and
arranged the flowers. The stereo was cued up to appropriate
music. And under the pillow in the bedroom was a bag of
old-fashioned marshmallow eggs for me. He had done all the
prep work and then slipped out the door. No sooner had the
last relative exited than I called Luke to thank him.

"Did you find the surprise?" He meant the eggs.

"I did! I'm eating them as we speak. Where did you buy
them?"

"In your local grocery, if you can believe it."

"And you bought them for me, even though you called
them vile?"

"Yes," he said. "I want to make you happy."

○

Luke was generous like that. He did me favors. He helped out. And he was like the gifts he gave—hidden treats that I always loved to find, but which added up to about six thousand empty calories. The more he made me search for him, the more I wanted us to stay home, watching TV and cooking dinner together. If I just had him alone, maybe the hunt would end.

Skittles

When I took my first dot-com job, I always explained it the same way.

"Have you heard of the Internet?" I would ask. "Or the World Wide Web?"

About 50 percent of my interlocutors had. They would say, "You mean the information superhighway?"

"Yes," I would say, "the information superhighway." I worked for Prodigy, which at the time was number two, after AOL, in online service providers. We were based in White Plains. I took two subways, a 45-minute train ride, and a 10-minute bus ride to and from work. Our jobs were ill-defined. Sometimes we had specific projects. Sometimes we were developing new projects. Sometimes we were trying to gather the resources to execute projects in anticipation of getting them green-lit. Nothing was ever green-lit. After a while, we came to understand that the company was

in the process of being sold. All assets were frozen. There was nothing for us to do but show up at work, try to think of projects that required no resources, and then try to convince people to do them. I was desperate to have something to work on. All I wanted was a normal job, where papers and email and phone calls came in, and one had an excess of work to get done in a single day. Was it too much to ask? Instead, there was my windowless office opening out onto empty hallways lined with closed doors. People were silent or, come to think of it, maybe they were out shopping at the nearby mall.

By eleven o'clock I'd generally given up on filling my time productively, and was already anticipating having a snack, but to have my one snack of the day in midmorning would doom my afternoon. I held out until lunch. Once lunch was over, it was all I could do to make it to three o'clock. Three o'clock—the workday hump hour. If you've made it there without already having the snack that you will most certainly have at some point, you know you'll make it through the day. If, for some wild reason, you're distracted or in meetings and don't have your snack until four, you're golden.

The vending machine was in the cafeteria, two floors up. I never took the elevator. Too fast. Up on the eighth floor, I stared at the vending machine for several minutes, even though I knew what my decision would be. A Peppermint Pattie looked sexy, but it was a single item. I knew it would disappear too quickly. Skittles had much more going for them. There was a gaggle of them, in various colors. That meant sorting, dividing, and rearranging. They were chewy,

and therefore longer-lasting. Yes, Skittles it would be. Making my choice at the machine and coming back down could take as long as twenty minutes. It was a thrilling opportunity. I made the most of it.

Back at my desk, unopened candy in hand, I had new energy. I made phone calls; I initiated new projects. This is the moment to savor—the time between purchase and consumption of candy. Senses aroused in the anticipation of bliss, tongue turning in anticipation, you have not yet crossed the threshold. Sweetness awaits, but the collapse of sugar low and guilt are held at bay as long as you linger in postponed fulfillment. Don't get me wrong—I never lasted long.

I spread the Skittles out on my desk in colored rows, lined up like an abacus, in descending quantity. I ate them by color, two at a time, with purples saved for last, naturally. Once the Skittles were gone, I was in the workday's home stretch.

It was a marriage of convenience. Working at Prodigy was like having a few drinks too many, making Skittles seem far more attractive than they actually were. Days were long and lonely, and sometimes you just have to take what's available. Or maybe I really did relish Skittles, and the job ruined them for me. They certainly had decent flavor and texture. I would still turn my head if a purple Skittle passed by.

Circus Peanuts

I knew I liked Shauna when I found out that she was a fan of Circus Peanuts. I was a near stranger. She was a work friend of my boyfriend, Luke, and I had just taken a new job at the company where he worked. It was not the wisest move. Neither Luke nor I was thrilled about the proximity, but it was, as they say, a job I couldn't refuse. Shauna had the cubicle next to mine, and saw me sampling the vending machine's offerings. Expecting a disgusted response, she confessed that Circus Peanuts were her favorite candy, with Peeps running a close second. I took the news in stride. I had had my Circus Peanuts phase, one summer working on Wall Street, but Shauna's passion made me realize that I hadn't given them full credit.

"Think about it," she said. "They are big and foamy and look sort of like peanuts. But they are orange. Peanuts aren't orange. And if they taste like anything, it's banana. Bananas

aren't orange, and they most certainly don't look like peanuts." There was a logical explanation for this. One expert claims that the original Circus Peanuts were supposed to taste like peanut, but the flavoring wasn't consistent, so they started using cheap, reliable banana oil. Regardless of the history, Shauna had a point. True to its circus origins, the candy itself was a mockery of candy. It said, I'm not what I look like, and I'm not what I taste like. So what? Life is a farce. Send in the clowns. I looked at Shauna with new respect.

At the end of my very first week of work, Luke and I broke up. We were watching TV on a Friday night. I was eating a bag of pretty peach gummies. I turned to him and said, "I feel eighty."

He said, "I think we should break up. I don't think this is working out."

"Shouldn't we try to make it better?" This was happening very quickly. We had never talked about our problems before.

"I already have tried."

I couldn't touch gummy anything for at least a week.

At work, Luke and I kept the breakup on the low-down. I had just started the job, and people hadn't met us as a couple. We figured what they hadn't known in the first place wouldn't hurt them. Shauna was one of the few people who knew me as Luke's girlfriend, but neither Luke nor I had told her it was over. The three of us walked to a bar for a

party. At the bar, Shauna made room so that Luke and I could sit next to each other.

"Don't bother," I said.

"We broke up," he added. Shauna was startled, but we all laughed it off. After my first beer I slipped into the bathroom, burst into tears, then came out to order another beer with perfect cheer. I didn't mind being the crying-jag girl for a bit. I knew it would pass. We would be awkward for a while, but soon work would be work, and our personal lives would go their separate ways.

I made sure not to overcultivate my friendship with Shauna. Luke had few friends, and I thought it would be inconsiderate to encroach on his territory. All this was to change. I had no clue how important Shauna would turn out to be. She was a clever, hardworking girl from the Midwest, but I should have known when I saw how much she liked Circus Peanuts that she had a complexity and humor that she didn't advertise. Our friendship would grow later, but our shared enthusiasm for candy was undeniable from the start. For her birthday I bought a plain paper bag and filled it with several packs of Circus Peanuts.

"I can't get over this," she said when she opened it. She gave me a big Ohio smile. "This is the most thoughtful gift I've ever received."

Mini Bottle Caps, Try Again

We had broken up, but we were trying to be friends. Luke went to Toronto for the weekend and came back with a pound of mini Bottle Caps for me. Who could imagine that such a thing existed? Why should those crazy Canadians be selling Bottle Caps in a major East Coast city while New York was a Bottle Cap wasteland? My extensive research of Manhattan and limited research of other boroughs had yielded only two highly inconvenient sources: a now out-of-business candy store on the Upper East Side, and a downtown store called Candy World, which was only worth considering when one (or one's friend) was on jury duty. But in Canada, in Toronto no less, there were not only bulk Bottle Caps, but also bulk *mini* Bottle Caps.

Candy manufacturers embrace this approach to product

extension. They must think, Well, people seem to like it— let's make it really big or really small. The results are fascinating. Size matters. Conversation hearts taste better big, as do SweeTarts, but the giant Hershey's Kisses do nothing for me. The big Tootsie Roll saves paper, but the bite-size pieces are ideal. Mini is often a mistake. Nobody wants less, and smallness hardens and neutralizes distinct textures. The best small candies are born small: Tart 'n' Tinies, Runts, Sugar Babies, Junior Mints, Chiclets. In truth, the mini Caps didn't really do it for me. As with jumbo conversation hearts, the larger size gave the candies a tenderness that was lacking in the taut, small version.

First Luke was doling the Caps out to me in daily cupfuls, but after a couple of days I started stealing refills from his drawer in the afternoon. This was awkward, so I made him give me the whole bag. The concentrated scent of sugar wafted from the paper cup.

I knew that Luke meant the gift to be kind. It was a gesture of peace. But I was disturbed by the Bottle Cap offering. Bottle Caps were my favorite candy. For anyone who knew me, they were an easy hit, but hard to find. I had a few friends who had, at one point or another, gone out of their way to track down Bottle Caps for me. All my associations were pure. I didn't want to have to associate them with a breakup bribe. They were meant for good, uncomplicated times. Accepting them from Luke, with the taste of our separation hovering in their sugary halo, felt dangerous. It was like taking candy from a stranger—a gift with too much intention. Oh, but of course I had to eat them—because they

were there. I ate them all day long, and on the way home, and at home, and on the way back to work in the morning.

Instead of smoothing things over, as it was meant to, eating the Bottle Caps that Luke gave me reminded me of what had been wrong. In the course of our relationship, he had given me tokens of his affection, but his heart had been missing. And now, too late, here was the shrunken assertion that I was in his thoughts. I knew the candies were a miserable little representation of sorrow, not genuine attachment. The sweetness tasted artificial. Well, it had always been artificial, but this time it was up to no good. I didn't want this miniature version of affection to woo me falsely. So I resolved that as soon as the mini Caps were gone, I would stop caring entirely. I couldn't eat them fast enough.

Swiss Chocolate
Ice Cream

There were days when mint chip reigned. Then the ice-cream industry began to permute its flavors endlessly, adding candy, cookie dough, swirls of caramel and fudge, and so on. I was quickly seduced by the strangely named hybrids that gave candy a refreshing new context. But sometimes the classics were still the best.

My grandparents lived on a hill, at the top of a long driveway bordered by azaleas. My grandmother's pantry was not to be rivaled. She always stocked chocolate soda, multiple flavors of ice cream, large Cadbury chocolate bars, and a full drawer of grocery store penny candy by the pound. Every Halloween she laboriously composed bags of assorted candies, tied with orange ribbons. No one ever ventured up her treacherous driveway to claim their prizes: One

banner year she had a total of two trick-or-treaters. The remaining bags lasted through months of our visits.

My grandmother also stocked my father's favorite ice-cream flavor. It was called Swiss Chocolate, and it was made by a local ice-cream store called Giffords. Even among ice-cream eaters who didn't favor chocolate or had been seduced by the new variations, Swiss Chocolate was widely heralded. Sometimes my grandmother lost track of the store because it moved more than once. There were periodic rumors that it was going out of business. But every so often, as the years passed, my grandmother would pull out a new carton.

My grandmother was a pack rat. There were two refrigerators, both overflowing with more food than she and my grandfather could possibly consume in a year. It never occurred to me that this was a fallible system until my grandmother died. One morning she got up early to let the dogs out, went back to bed, and there her heart stopped. In the days after the funeral, we started cautiously getting rid of some of the clutter in the kitchen. There were giant plastic bags assembling a lifetime supply of rubber bands. There was an enormous collection of bottles that I packed up for recycling. One freezer was full of undated meat packages, all of which I threw away. My father found a preserved piece of his bar mitzvah cake. A can of Coke had exploded in the spare refrigerator.

"Was it like this the whole time, or do you think she was letting things go?" I asked my father. He just shrugged. He was disposing of a ream of brown paper bags. High on a

shelf I saw an unopened box of chocolates, individually wrapped and packaged in clear plastic. I took it down hopefully, then dropped it to the table with a start — it was teeming with maggots. My grandfather was watching me. I silently put it in the trash.

I was itching to organize the place, and could tell that my father felt the same, but we didn't want to upset my grandfather further by changing too much too fast.

"Save it!" he barked when I ventured to dispose of the extensive jam jar collection. He hadn't entered a grocery store, much less prepared his own food, in over sixty years. We didn't know if he was capable of making himself dinner, much less whether he would need to store leftovers in a jam jar. And yet we were all going back to work in two days, leaving him to fend for himself. It didn't seem right.

My grandmother's house was loaded with sweets, but I never saw her touch any of it. She had a soft, grandmotherly body. She must have been a closet candy eater — keeping it openly but opening it secretly. This was true for my other grandmother too. She kept Andes mints in a little bowl on her table for years. But my parents, with second generation (at least) sugar genes, kept a candy-free house. I never learned to live with it. The result was that, with household candy stocking on both sides of the family, I was quite the opposite. Nothing lingered on my shelves. Shelves? My candy never even made it to shelves. When I bought candy, I came directly home to eat it. The idea of keeping it in the house was utterly absurd. It would never work. My purchase size was my serving size, without fail.

My father opened my grandmother's freezer and scanned its contents. Pulling a quart of ice cream out of the freezer, he sniffed it.

"Want some?" he asked. I ate mine on the step down into the garage, figuring it was the last Swiss Chocolate I would taste.

Sugar-Free

Four months after we broke up, Luke told me he wanted to talk to me. I figured he was going to say that he missed our friendship and wanted to see me more. Instead, he informed me that he had begun dating the only person who reported to me at our company. When he told me this, I started hyperventilating. My breath loud in my ears, I stormed across the street, away from him. Then I crossed back and turned on him in a rage of pain and disgust. My voice was high and unfamiliar. Later I realized there was a word for it: I was hysterical. The idea that he couldn't look farther than the desk across from mine for his next girlfriend was utterly outrageous. The instant he informed me, after work on a Friday, a flip book of painful realizations riffled through my mind. I suddenly knew that they had played hooky together the week before. I realized that the cute "long-distance" romance she had conducted via email over

the holidays had occurred while he had been overseas. I remembered the attention he had given her at the Christmas party. He was telling me on the street outside our office, as if he were going beyond the call of duty by letting me know, and I nearly spat at him. "At least now I don't have conflicting feelings about you," I snarled, "since all that's left is hatred."

My own drama shocked me. He came up to my apartment, where he hadn't been since we had broken up. I said, "Please, say anything to help me forgive you." He didn't apologize—if only for the inconvenience to me—or make any effort to defend his actions by claiming that this was true love. He just waited uselessly, so he could tell himself later that he had done the right thing. I could tell from his shirt selection that he was going to meet up with her after he had delivered his news.

"I think you should leave," I said. The door closed heavily. I wanted nothing more to do with him.

In the office the next week, Shauna approached me. "Is something wrong?" she asked.

I looked at her. I had been avoiding humans since Luke had dropped the bomb of his new girlfriend's identity. In my fraught state, I felt extremely vulnerable. "I'm sorry, but I don't think I can be friends with you anymore."

"Would you like to take a walk?" she asked.

"Okay."

We headed out to the Hudson, where the melting snow was deep and wet. We were both wearing inappropriate footwear, but I, at least, was numb. On our walk I explained

to Shauna that Luke had done something that I found so reprehensible that I couldn't deal with having any friends in common with him.

"Hilary, just tell me what happened."

So I told her, and she said, "That's a horrible thing to do. I won't speak to him again." And that was that.

Shauna never said another word to Luke. Instead, she spent some amount of every day explaining to me that I was too good for him. "You sparkle," she would say. "He is Beige, and his new girlfriend is Beigette. You are too fabulous for either of them. I'm glad they have each other." Mutely appreciative, I turned to her for regular ego boosts as each day overwhelmed me.

"You're my savior," I told her.

"I think we should send Beige a thank-you note for fortifying our friendship."

I had nothing against my employee. I was civil to her, acknowledging the situation and expressing hope that it wouldn't interfere with our work, but I looked through Luke when we passed in the halls. He was dead to me, or at least comatose. They ate lunch together. They talked in murmurs on the phone. They left work together. The only thing that was subtle about them was any effort to be subtle. I went through the motions of my job, but in the evenings I fell to the floor in a heap.

"I don't even want to date him," I sobbed to a doctor friend. "What is wrong with me?" He recommended Xanax.

○

Barely holding myself together, I couldn't eat candy, or ice cream, or any other major food group for that matter. Much as I was willing to eat however much sugar it would take to break this darkness, the idea of sweets had no appeal. My candy battery was dead. This had never happened before. It had always been self-recharging. And now, in the middle of the storm, there was no candy-light to guide me. More than once I stood in front of the drugstore candy counter contemplating a jump-start. Not even a tiny spark of desire. That's when I knew I was in a seriously bad way. Every morning I bought a Power Bar and took pains to nibble on it, without hunger, as the day passed. "You are disappearing," Shauna would say with a girly mix of concern and flattery. We both knew it wouldn't last, and that I should probably appreciate it while I could. I went to the gym and pretended I was in *Rocky*, or an Ashley Judd movie, where I was building up my strength to take on the adversary. In this case my adversary just happened to take the seemingly harmless form of the back of Luke's head, and the fight was seeing it every day.

I wasn't myself, but I knew it was temporary. After some period of time, my employee told me that she had found another job. I congratulated her and hoped it was an excellent opportunity. On her last day, a colleague came up to us to bid her farewell. He asked her how she felt about saying goodbye.

"It's bittersweet," she said.

"Well then, I'll take sweet!" he said jovially.

"I guess that leaves me with bitter," I said. She and I made eye contact, and we laughed together.

○

Whenever I eat candy I have some level of guilt. I know from reports that sugar is unhealthy. I could still stand to lose a few pounds. But on the Luke diet I dropped a couple pounds a week without even trying. After six weeks, when I looked in the mirror I couldn't find any weight to lose. In two months I went down three sizes. Shauna took me shopping. I bought size-two leather pants. For the first time, I knew that I could eat whatever I wanted, and I would still fit into those pants. But I couldn't even manage to go food shopping. I had no appetite, and I had no joy. Except those buttery leather pants. They fit me for that one terrible winter.

A Heart-Shaped Box
of Chocolates

I am baking cookies on Valentine's Day. The buzzer buzzes.

Doorman: There's a delivery for you coming up.
Me: Really?
Doorman: It's chocolates.
Me: Really??!!
Doorman: Oh, um, is this Hilary? I'm sorry. I have the
 wrong apartment.

OOOOOOOO

Part Three

JUST
DESSERTS

OOOOOOOO

Taffy

I was committed to my job and had no desire to divorce it for emotional hardship. But then, like an angel, the head of a fascinating new company approached me to do business development and asked me to name my price. When he met it, I put myself in the hands of fate and accepted the position. Getting away from Luke was not the reason, but it was certainly a perk. My spirits lifted immediately, and my appetite returned with them. To celebrate, Shauna and I went on a pilgrimage to Economy Candy, an old-school cheap candy store on Manhattan's Lower East Side. We had heard that it was the penny candy store that we were too young to have experienced.

"Meet me outside," Shauna said. "I want to go in together."

Beyond the threshold was a pleasantly disordered store with enormous bins of hard candies at low, low prices.

Unlike the uniform bins of today's airport candy stores, the merchandise here was piled and stacked in a few converging systems that ran from floor to ceiling. It was hand-priced, and novelty candies huddled brightly next to gourmet selections.

I wasn't terribly selective when it came to candy stores. I liked seeing what a drugstore chose to carry. I was fond of the shops where you could fill a bag with assorted candies by the pound. A corner deli suited me fine. And then there was the fancy candy store on the Upper East Side called Dylan's. Shauna and I had been there. It was the F.A.O. Schwartz of candy stores. A soundtrack of candy theme songs played on a loop. The scent was an intoxicating olio of candies rare and common, old and cutting edge. A rainbow of colors made the two floors confusing and fantastic—like being lost in the center of a spiral swirled lollipop. The stairs were translucent, inlaid with gummy art. There was a larger-than-me Pez dispenser. They had marshmallow eggs at Easter, Flakes, and any color of M&M's that might ever exist. There was fresh fudge, imported candies, and even candy gift baskets. Some of it was pricey, but I loved Dylan's, and once it existed it was hard to believe that it hadn't been there forever.

Economy, on the other hand, had actually been there forever, or at least since 1937. It was the faded denim version of Dylan's ready-to-wear. The corners were musty, and even the bright candy wrappings seemed tempered by sunlight or wisdom. Surrounded by the relics of the Jewish Lower East Side, buying candy there was like traveling back in time. We circled excitedly, murmuring with respect.

I didn't want to buy just to buy. I wanted to find something new or something that I couldn't get elsewhere. Finally, when the guy behind the counter informed us not unkindly that they would close promptly at six, I made my selection. Swiss petite fruit (I confess to some gratitude that a half pound was the minimum quantity allowed), and a strange-looking "Old-Fashioned Taffy" that was appealing because it was large and very flat, like a business envelope. Shauna went for an assorted mix, just because she couldn't believe how very economical Economy Candy was.

Out on the street, we walked north. I still felt tender—it was as if my wound had been bandaged, but I was fragile and needed to be handled with care. When the wound healed, the new skin would be like a baby's, soft and new, but sensitive. Shauna had convinced me to come back out into the world. Economy Candy was just the beginning. I peeled the waxy paper off the taffy and tore off a piece. Shauna was curious. "What is it like?" she asked. I paused while I savored the plastic texture.

"If everything in the world were made of candy, this is what your desk would taste like." Then we both started imagining the rest of that world—the chairs, clocks, towels, light bulbs—and we chewed in silent reverie for several blocks.

Bottle Caps Regained

Chris and I had been on three partial dates, three evenings that began with us socializing as part of a group and ended with us on my couch, using my restrictions on clothing removal to set the pace of our groping. Chris was already bitter about the couch. It was a smart bachelorette's love seat. Green velvet, alluring, but short enough to prevent eager boys from moving too fast. Tonight, he had insisted, he wanted to take me on a "date date." He also wanted to end the evening at his pad. I was curious to see it. A man's apartment is Cliffs Notes to his life.

He was early. Not on time. Early.

"Couldn't you have walked around the block once or twice?" I asked as I opened the door. He had no head, only flowers. "Chris? Are you back there?"

"These are for you," he said. I was already putting them

in water. His hair was dark and curly, and he was wearing a severely out-of-style shirt. A man would have to work hard to make me notice a fashion mistake. It wasn't part of my Date Evaluation Procedure, but what can you do when a man is standing in front of you wearing a button-down shirt with no collar? And yet, it was immediately apparent to me that this relic of the '80s was his favorite shirt. It had an ink stain on the pocket, but he had chosen it in hope that it was still wearable. Because it was his very favorite. I smiled at him.

It was, indeed, a date date. There was a fancy dinner with a bottle of wine. Then there was a rooftop party across the river in Williamsburg. Chris excused himself to talk to a friend, if I didn't mind. I didn't mind. I spoke with a fellow who told me all sorts of interesting facts about acoustic warfare until Chris returned. He joined our conversation, then eventually steered me to the side of the roof. We looked out at Manhattan. It was a windy spring night. He offered me his jacket. He was well trained and his effort was A-plus. Noted.

"I know I have no right to say this," he said, "but I'm actually surprised at how jealous I was when I saw you talking to that guy."

"Really?" I said. "How jealous were you?"

"I felt sick to my stomach," he said. "I can't remember ever feeling like that."

"Are you a creepy stalker type?"

"Not that I know of," he said, "but you might want to be careful."

○

His apartment was clean, generic, and functional. The matching wooden furniture appeared to have been purchased in one fell swoop. Some things, like the burgundy and forest green plaid couch, may have been selected by his mother as "masculine." In fact, forest green was getting more than its fair color share. No art. No girlfriend or girl friends exerting influence. He is a man of simple tastes. He works hard. He reads, but doesn't have time to bounce against his own walls. I saw my business card on the entrance table. My little mark, staking its territory.

"I have champagne to celebrate our date date," he said.

I shook my head. It was too late for champagne.

"And I have a little dessert. Don't ask me why it's in the freezer." He pulled out a pack of Bottle Caps.

"Why is it in the freezer?" I asked.

"I thought it would be a good hiding place?" Chris wasn't the first boy to give me Bottle Caps. Even Luke had gone that route. A fellow didn't need to be a rocket scientist. Nor did the candy have a magical effect on me. I wasn't Edmund, seduced by the White Witch's Turkish delight on my first trip to Narnia. I was cautious, but open. What mattered most to me was the spirit in which the gift was given. Chris watched and smiled as I dug in. His eagerness was sweeter than candy. I was impressed.

"Where did you find Bottle Caps?"

"I have my sources," he said.

Twizzlers

My friend Shauna was in a grocery store with a guy. "If you could only eat one kind of food for the rest of your life, what kind of food would it be?" she asked him.

"Easy. Twizzlers," he responded without pausing to think.

"I think that's when I started liking him," Shauna told me. "You understand."

Yes, I understood. Twizzlers have the same twist as a barber's pole, and likewise seem as if they could go on spiraling forever. What better candy to stock one's office candy jar? The jar people—that strange breed of workers who are able to keep jars of candy in their offices at all times without going to town on them—the jar people know that the best jars are always full, magically refilling fairy tale candy jars.

And the substantive Twizzler, with its endless twizzle, is the candy of choice.

Steve was our jar person, no holds barred. His office was stocked with a jellybean machine (with a tin of pennies provided by Steve), a bowl of Hershey's Kisses, and a five-pound canister of Twizzlers. Steve had an instinctive understanding of the need for candy balance. His candy had none of the customary, though unspoken, restrictions on time, frequency, or quantity. I didn't have to have a meeting with him to go into his office. I could go as many times as I wanted every day. I could take huge handfuls. Steve's response to any admission of greed or binging was always, "That's what it's there for!" And no matter how much I ate, the candy was never depleted.

If anyone could have dented Steve's supply, it would have been me. Some days I would get on a Kisses run. I only took four at a time, but I discovered a new way of eating them. Sucking chocolate is usually satisfying, and makes sense because, unlike with hard candies, the flavor emerges at a steady rate. What I discovered was that chewing Hershey's Kisses offers a whole new sensation. There was basically only one major chew per Kiss, which broke the candy's integrity immediately. The Kiss, with greater surface area now, dissolved more quickly, so my mouth was instantly full of liquid chocolate. A great new sensation, but the speed of execution triggered a few complications.

First, I started eating them fast, like popcorn. Then sometimes, just after the bite, the phone would ring. I would take the call, and only then would I realize that I had missed

out on the whole Kiss experience. That's when I would have to go back to Steve's office. "Serving" became a misnomer for my four Kisses. It was more like there were four "reps" to a "set."

But Steve offered more than Kisses. I had hardly ignored Twizzlers previous to Steve's office, but he really gave them a chance to shine. Once relegated to dark movie theaters, I knew and loved Twizzlers for their unique waxiness. It took a relatively long time for me to finish a Twizzler, which slightly increased their chances of lasting through the previews. Junior Mints were hard to resist. They had more flavor and melted with gentle charm. But Twizzlers had the staying power that is critical for movie candy.

Now the red ropes emerged to bathe in the fluorescent lighting above my New Media cubicle. Because Steve's office was open to the entire staff of our small company, Twizzler consumption was heartily public. It was not unusual for me to bring a three-vine dose for sustenance at a meeting, and my preparation frequently inspired the other attendees to similarly fortify themselves.

What amazed me most was how much fortification a five-pound canister of Twizzlers truly provided. I, and my simpatico co-workers, indulged on a daily basis, but Steve's well never ran dry. The stability was compelling. I finally had a job where I was happy; I had met a nice fellow; I wanted my new life to string on and on with sustained flavor-release. But in candy format, long-term commitment had its drawbacks. The Twizzlers were a constant presence, and I was used to eating whatever candy was available until

it was all gone. Like a baby bird, I was quite willing to go until I exploded. Sometimes I begged Steve to save me from myself.

"Please," I would tell him, "take me out of my misery." But he would just laugh, shrug as if it were out of his control, and say, "That's what it's there for!"

Icing Off the Cake

If my parents had been like Steve, so relaxed and giving about candy instead of concerned about the effects of my sugar intake on my health, would candy have been a childhood passion that faded into disinterest?

My father recently said, "You remember the sugar and butter experiment, don't you?"

I didn't remember.

"Well, you must have been about nine. Somehow your mother got it into her head that perhaps you were obsessed with sugar because it was forbidden. So we decided to give you as much as you wanted. You don't remember this?" It was Father's Day. We were eating our prix fixe desserts.

"No, not at all."

"Well, we gave you a cup of sugar and a stick of butter—"

"Was it confectioner's or granulated sugar?" I asked.

"Granulated, I think," he said. "We put the sugar and the

butter on the table and told you to have at it. You sat there, mixed them together, and ate the whole thing. Then you got up from the table, said, 'Thanks, guys,' and walked away."

"That's a beautiful story, Dad," I said.

My parents were trying the Mrs. Piggle-Wiggle approach. Mrs. Piggle-Wiggle is a character in kids' books whose cures for tattletales, bad table manners, interrupters, et cetera, often involve giving the offender a taste of his own medicine. But Mrs. Piggle-Wiggle would have taken it a whole lot farther than a cup of sugar and butter. She would have given me all the candy I wanted, and more. Much more. For weeks until I had had enough and was demanding a salad. Who knows how the experiment might have paid off had my parents seen it through.

Before I hit adolescence, my parents only gave sporadic attention to my sweet tooth. Sometimes they thought that making a big deal about it would only make it worse. Sometimes they thought that if they could convince me to try fruits and vegetables, I might not need the candy. And much of the time, it was more worrisome that I wasn't at the top of my class, that I didn't seem to be popular, and that I spent most of my time reading in bed. So they sort of let me get away with it, and it wasn't until later that I found out about the candy gene.

Necco Wafers

As an adult, I asked my mother what she thought about my sugar habit. She said, "You came by it honestly." It was only then that she revealed, for the first time, that she had spent my youth hiding her own predilection for candy from my brother and me.

"Did you eat sugar out of the box?" I asked.

"Yes."

"Did you eat spoonfuls of cocoa powder?" That too. She revealed that even now, as a middle-aged woman, she would go into a candy store and stare at marshmallow eggs, arguing with herself about buying them.

"I love Smarties," she confessed, "but I never buy more than a few packs." My whole youth was littered with the wrappers of candy I had eaten in secret, feeling alien and disobedient and that if I were normal I would be eating fruit. And here was my mother describing a familiar dynamic.

"Mom, did you ever consider that maybe if you'd come out of the closet, I wouldn't have been so crazy about candy?"

"You wish."

Again I contemplated whether, if it had been handled differently, my passion for candy would behave itself. Was it all a forbidden fruit syndrome? *Prevention* magazine touts a book called *The Ice Cream Diet,* by Holly McCord. Describing the benefits of the diet, one expert says, "When we tell ourselves we can't have something, we immediately focus our attention on what's forbidden, which increases our desire and chances of losing control." There was no question that my attention was focused on sweets. On the other hand, I indulged my desire so regularly that I couldn't exactly call it forbidden.

But what if our family had approached candy together, as a fun indulgence? On a trip to Dylan's, I witnessed children holding their own shopping baskets, filling them recklessly. Recklessly! I stared in horror. How could their parents allow them to buy literally ten pounds of candy at one time? Then I stopped myself. Who was I to talk? Maybe these kids were actually on the "Mrs. Piggle-Wiggle diet." Maybe they would be just fine. Better, even.

When I think of being a parent, I feel confident in my ability to rear a couple people. I can envision reading *Goodnight Moon* several times a night, making up answers to scientific queries, and kissing wounds. I would probably even figure out how to cook. But when I try to think of how to manage their relationship with sweets, well, I think I'll have to leave that to the other parent.

○

When all was revealed, it turned out that my mother and I had several candies in common: marshmallow eggs, Smarties, Necco Wafers. When I found out about the Necco Wafers, I knew we were dealing with a genetic inclination. I was proven right a few weeks later.

My mother and I were over at my brother's, babysitting for my nephew and niece. My three-year-old nephew surprised us by saying, "I want a Necco Wafer."

My mother and I looked at each other in surprise. How did he know what a Necco Wafer was? His father was a Spree junkie. Maybe in our family it was the most natural sound a toddler could form: Ma-ma. Da-da. Nec-co.

"You have Necco Wafers?" my mother asked her grandson.

"Yes," said Asher, very serious, "they're in the pantry. I'll show you where they are."

I could see his future. My brother had spent his childhood with a candy thief, losing whatever he saved to my relentless craving. His son had the same tendency. Give the kid five years, and the security of my brother's candy would be challenged again.

My mother looked at me mischievously. I looked back at her. We both knew that we should let his parents decide if and when Asher could have candy. But it soon became clear to me that my mother had no intention of giving him a Necco Wafer; she wanted to find out where they were kept so that she could help herself after the kids had gone to sleep. She followed him into the pantry. Knowing the extent of her sugar history did make a difference. We were both crazy.

But we are not alone. According to Necco, over four billion Wafers are sold each year, which averages out to 120 Wafers consumed every second of every day throughout the year. I wonder how many of them are in Denmark.

Cotton Candy

Nothing had gone wrong yet, but nothing would have. Chris and I were still trying to impress each other.

"I need to go to Centralia," I told him. He had read about Centralia. It was a town in Pennsylvania where an underground mine fire had been burning since the '60s. The government had evacuated most of the town and razed almost all the houses except for those of a few die-hards.

Chris was game to plan an excursion right away. He didn't have a car, but he would rent one. He would figure out where to go. All I had to do was show up. "You know it's a bit of a drive. We might want to stay out there and make a weekend of it."

"I know," I said. He was psyched, I could tell.

Chris showed up in a large red sports-utility vehicle.

"When you said we were going to stay overnight, I didn't

realize you meant in the car," I said as I climbed up into the passenger seat. There were maps and a couple guidebooks to Pennsylvania. He had done his research.

Centralia was a town on a grid, with a main strip and streets running in both directions. But all the buildings were gone, and the lots were so overgrown that you could barely see the streets. We turned onto a side road. The grass was up to the car windows. Ghost driveways with mailboxes at the edge led up to nothing. There were a few surviving houses, anomalous mowed lots with cars in the driveways. These owners were dying out, but some of them had taken over the lots on either side. Why not? They were squatters anyway. The town was condemned. Who would complain?

The fire had destroyed part of Route 61, and the official highway now bypassed the danger zone. We walked down the deserted part of Route 61. It was steamy and bare, with a wide, deep, mildly smoky crack in the middle, practically down the yellow line. The side of a deserted highway—a perfect spot for a picnic. We sat on the slope above the shoulder and ate sandwiches, looking down at the empty asphalt as if it were a river. Seeing the premature ruins of contemporary society was creepily post-apocalyptic.

"I feel like we're the last two people alive in the world," I told Chris.

"You know what that means," he said, not missing a beat.

"?"

"We must procreate!" he said.

No thanks. I didn't feel like getting sweaty on the post-apocalyptic roadside.

After our picnic we headed south toward a drive-in. My navigation got us lost. I wanted lunch-dessert. There was a town fair on the side of the road.

"I have a new rule for us," Chris said. "All visible fairs must be visited."

"Yes," I agreed, thinking about cotton candy. "You can win me a stuffed animal and then we can go to the drive-in."

Cotton candy was invented in 1897 by two guys from Tennessee, who brought their "fairy-floss" to the St. Louis World's Fair and sold it in wooden boxes. It's too bad that the name got changed. Fairy-floss suits the sugar that spins from crystals into clouds and then, when the spell is broken by human tongue, back to crystals.

It was my first cotton candy in a long time, and it was a letdown. When I had gone to the circus as a kid, the performer who inevitably impressed me the most was the person at the cotton candy booth, with his centrifugally whipped sugar clouds. That is what going to the circus meant to me: cotton candy, guaranteed. As soon as I was a teenager, in control of my own destiny, my serving size for cotton candy was three spools at the rare events where it was available.

Now, ten years later, I still found the art of it appealing. The scent was just as alluring. But when I ate the cotton, what it melted into was, well, unimpressive. Red sugar in my mouth. And the way the last fibers clung to the flimsy paper cone was suddenly unpleasant. Shrug. I couldn't bring

myself to finish. And then there was Chris, proudly display-
ing a lime green alien that he had won for throwing a bas-
ketball into a ridiculously far and tiny hoop. The cotton
candy was discarded and forgotten, its memory betrayed. It
was all fluff and no substance anyway. Who needed it? Cer-
tainly not me. For once I was distracted from the charms of
dessert. The images before me were more nuanced than
spun sugar, and suddenly more interesting. A town had been
on fire below the surface for many decades. The boy beside
me had an alien in hand and a heart of gold. And I was off to
my very first drive-in.

This Woman Needs Help

The shrink I had started seeing when Luke worked me over decided that I had recovered.

"I think we should talk about terminating," she said. These were the magic words that I thought New York psychiatrists never actually uttered.

"You think I'm better?" I was incredulous.

"Don't you? You seem very happy to me," she said. It was true. Things had been going well with Chris for many months. I had no complaints.

"But . . . but . . . are you saying that all it took was the right man to make me happy? That's terrible!"

"I think you are a well-adjusted person. Circumstances have converged nicely for you. It might have something to do with Chris, but regardless I don't see much for us to work on (but if you do, we should address that)."

Then I remembered. "What about my candy addiction? We were supposed to figure that one out."

She stood her ground. "I don't see that as a psychological problem, although it certainly doesn't seem very healthy. I recommend that you see a nutritionist."

A nutritionist. Now, why hadn't I thought of that?

Here's what I figured a nutritionist would say: "You're filling up on candy instead of food. If you just ate more fiber, fruit, and vegetables, you wouldn't feel hungry for candy. Also, you have trouble figuring out exactly what to eat, so you turn to something easy and convenient. Here are some simple recipes. Here are some healthy snacks. Here is a detailed analysis of your stool specimen. Follow this all-wheat-gluten menu for a week and let me know how it goes." Great. I already know that I can buy a banana instead of candy. I'm no junk-food junkie. I'm no stranger to whole grains. Alpha-omegas are my best friends. I already had a nutritionist: me!

I loved candy. But too much was too much. And sometimes I felt I ate candy not because I wanted a little something sweet, but because I wanted a lot of something sweet, endlessly, in a not-very-healthy way. I wanted eating candy to be a decision instead of a compulsion. Maybe I could enjoy it more if I ate it less. I wanted guilt to disappear. And my metabolism wasn't getting any younger to boot.

So a while after my shrink hour became my own again, I decided to try going to a hypnotist. I couldn't stomach the nutritionist, but a hypnotist might charm me out of my

addiction. The hypnotist lady was instantly more analytic than I wanted her to be.

"You don't understand," I told her. "I passed therapy with flying colors. I'm done. Now I just have this pesky little addiction to eradicate." I looked around for the pendulum. No pendulum, but a few cats, which were a good sign. Maybe she was a witch.

Then she explained that hypnotism is widely misunderstood. I wasn't going to abracadabra stop eating candy, but through the power of suggestion I could remind myself that it was not a healthy choice, and that I was a healthy person, and that I make my own decisions about what I want to eat. It all sounded very reasonable. I was disappointed. But I took the tape that she made for me—a sort of peptalk slash guided meditation that reminded me how important I was and how in control of my own destiny I could be. Listening to the tape was a nice, feel-good experience, although I still harbored hope that it would help me do a back handspring or play Rachmaninoff.

The hypnotist lady suggested that I listen to the tape every day. I was good at first: I listened to the tape in the morning, ate healthy food all day, and exercised regularly. Then I discovered that if I didn't listen to the tape, I wouldn't let myself eat candy, because then I would be in trouble (with me) for not listening to the tape. That worked extremely well for a while. And then I sort of forgot about it entirely. That's when I realized that I was becoming a fad diet type person. I was turning into the kind of person whose strategy for changing part of herself was the only thing that

ever changed, but who never actually summoned enough willpower to make the change.

I didn't need a tape. My head was a broken record anyway. Every time I wanted candy, I could just have an argument with myself. *Good luck,* my health-nut side told my sweets side. *May the best self win.* Then the argument began:

Sweets: Mmm. How about a 99-cent bag of gumdrops?
Nuts: Nah. We're not doing that anymore.
Sweets: But we were good yesterday, and we went to
 the gym today.
Nuts: Exactly. You want to ruin the benefits of the gym
 by consuming empty calories?
Sweets: Well, yes.
Nuts: See that skinny girl by the counter?
Sweets: Barely.
Nuts: I bet she hasn't had a Smartie in a year.
Sweets: I bet she's dumb as a tree.
Nuts: Don't you want to fit into last year's pants?
Sweets: I guess so, but Smarties have no fat.
Nuts: Empty calories convert to fat. Why don't you pre-
 tend that you *already* ate the Smarties?
Sweets: You suck.
Nuts: Don't you have some raspberries at home?
Sweets: Oh, hush.

Here's how the argument went the rest of the time:

Sweets: Hey! Get those Zotz! You won't find them
 again soon.
Nuts: Great idea!

I am always going to have this fight with myself. I know it, because it is the same argument my mother described having with herself staring at those marshmallow eggs. I think of those internal voices as my willpower. Much as I want my candy consumption to dwindle holistically, I recognize that my situation calls for some level of self-conscious restraint. If Nuts, over time, gets a little faster, and wins slightly more often, then at least if my head isn't normal, my intake may get close.

No, Thank You

Aging is about refining one's taste, while respecting the taste of others. If one takes things too far, one becomes a crank. I can honestly say that as a guest in someone's house, office, or ladies' lounge, I would gratefully accept any of the below, but these are a few of the candies I never buy:

1. Velamints: Try eating an entire pack of Velamints in one sitting. You will never, ever do it again.

2. Tropical Skittles: As a casual Skittles consumer, I have to say, with due respect, that certain of the tropical flavors clash with each other. How hard can that be to avoid?

3. Chunky: When Chunky was released, the TV ads, whatever they were, were salivatingly good. Imagine my disappointment when I found out about the raisins. As far as I, a non-fruit-eater at the time, was concerned, this was a

serious error in judgment. Cheeseburgers are good. Reese's work. But when fruit and chocolate are together, one is melting and the other is resisting. You need two mouths to handle the conflicting processes. The only fruit that I can handle in chocolate is the liquidy center of a gift chocolate. I'm told there are plain Chunkys, but my trust has been violated. Chunky will never earn it back.

4. Black licorice: People either are or aren't. I'm not. But I think it's very classy.

5. Dark chocolate: Again, a sophisticated choice. If I were a dark chocolate eater, my whole life and personality would be different. I would know how to dress "office casual." I would be better at wearing hats. I would be able to tie a cherry stem in a knot with my tongue. I would not find self-deprecating humor funny; instead, I would find it puzzling. And I would certainly have better cooking skills.

6. Mary Janes: The bane of piñatas. Mary Janes are simply too, too much of a challenge for my teeth.

7. Whoppers: The Whopper is a decent stand-in for a Milk Dud, but I would never seek one out.

8. Anything crunchy: Nestlé White, Krackel, Crunch, Kit Kat, Reese's Sticks, Snickers Crunch, Whatchamacallit. Crunch brings too much air with it. I realize that the crunch is very trendy. It's a favorite in product extension. I'm not going to argue with the crunch market, but I'm not buying. Except, for some reason, Twix. (Rice Krispies Treats tiptoe the border between candy and pastry. So long as the chef doesn't skimp on the marshmallows, they are another exception.)

9. Hard candies: I like to believe that the inventor of

hard candies said, "Let's produce a cheap candy that people buy in order to give away." Hard candies are for banks, retail outlets, real estate agencies. They make good sense anywhere you want to give away candy, but you don't want people to be greedy. Go ahead, put out Hershey's Hugs. They'll last a day. But line your lobby with bowls of lemon drops and you'll refill once a month. Exceptions: butterscotches and root beer barrels.

10. Coffee and coconut: I don't look good in gray or salmon. I think I might be an Autumn. Coffee doesn't work for me, not even coffee ice cream. And Mounds taste like shredded paper. Not my thing.

11. Razzles: What is annoying about Razzles is not so much the candy itself, although the "hidden gum" notion is more successful in Blow Pops and I take issue with gum anyway. The annoying reality is that many people think they are absolutely alone and original in their Razzles nostalgia. This is also true for those pretty candy buttons that can't be eaten without trails of their paper backing. These are the candies that everyone loves to remember, but no one truly loved to eat.

12. Redundant candy bars: Oh Henry and Pay Day. There must be loyal followers, but if I'm going to have nuts in my candy, which is a big if, I'm going to get a Snickers.

Starburst

Chris was a geek. The primary symptom was his predilection for elaborate 24-hour road races that were occasionally held around the country. In these informally organized rallies, vans full of technology-laden nerds solved complex puzzles to get from one clue to the next. The biggest of all these games was a charity event to be held in Seattle, and Chris wanted me to join him.

There were six of us in a van. We found one of the first clues in a fake newscast being broadcast on the TV screen of an electronics store. Another clue gave us tickets to the Mariners game, and another required us to buy a dozen eggs and figure out why they had been injected with different colors of dye. It went on like this. Chris was very good at solving clues. I was, well, a beginner. Hours into the game, we had to find homonyms in the menu of a restaurant, swim out

to a dinghy in the middle of a lake, and go into a house party to retrieve a clue from kids who were staging a knife fight.

At three in the morning, just as we were starting to fade, a clue brought us to a large building near the airport. We were led to a simulation flight chamber, suspended in the middle of an enormous room. Under the instruction of a pilot we had to take off, fly around the Space Needle, and land. Needless to say, this was a complete surprise at three in the morning. We couldn't believe it. We were beside ourselves with amazement. As we ran out of the building, having completed the task, we were given a pizza and a bag of candy and chocolate bars for a post-midnight snack.

Back in the van, after wolfing down two slices, I started looking for the candy, which had somehow immediately disappeared among the reference books, walkie-talkies, and paper that littered the van. Everyone else was onto the next clue, but I secretly kept looking for the dessert. I knew I was looking longer than I should have. All my puzzle-solving skills were gone. I kept my eyes open, but that was the best level of participation I could summon.

At dawn one of the puzzles led us to the Space Needle itself. It was five in the morning, but a man was waiting there to take us up in the elevator. At the top he opened a door, and we climbed a workman's ladder up a narrow chute onto the roof of the observation tower. It was windy, and the sun was rising. There was one more ladder, up to the Needle itself. I climbed to the top. I was the tallest person in Seattle at that

moment, but I wasn't looking at the view. There, high in Seattle, was a pile of cassette tapes—our next clue.

We returned to the van again. Everyone was listening to the cassette, which they thought had a garbled rendition of the *Barney Miller* theme song. It was then that I finally located the candy under the third row of seats and said in a very modulated tone, so as not to disturb my teammates, "Hey, does anybody want some of this?" There was no response. It was morning and we hadn't slept at all. This was the fuel I had been craving. I ate two packs of Starburst in quick succession and a Milky Way for dessert. I was back! With new superhuman powers I turned to my teammates and suggested that they stop playing the tape and break it open. They looked at me with curiosity.

"I'm telling you!" I said, pointing out that the case said, "Books on Tape, Volume 0."

"Volume 0. That means we don't need to listen to the tape," I told them. Chris was already pulling out a screwdriver. Seconds later we were stretching out the coils of tape, squinting to read the tiny print that we found there.

At the department store Nordstrom's for the next clue, our team dashed out of the van, leaving me and Chris, who was driving, alone for the first time in hours. I was sticky and tired. I got out to go help, but Chris pulled me back.

"Next week," he said, "can I see you every night?"

"Yes," I said, and ran out to find the Nordstrom clue.

The Truth about Circus Peanuts

Shauna went home to Hudson, Ohio, for the town's annual ice-cream social. When she came back, we went to a movie. She brought me back a bag of Circus Peanuts. Our friendship had been founded on the first Circus Peanuts that I gave her, and now they were a token of that friendship. We read the wrapper:

> Ingredients: Sugar, Corn Syrup, Gelatin, Glycerin, Modified Soy Protein, Sodium Hexametaphosphate, Pectin, Artificial Color (FD&C Yellow #6), Artificial Flavor.

I had never read the ingredients before. Then I noticed, in tiny print at the bottom of the label:

> May contain traces of peanuts/nuts.

Who knew that Circus Peanuts had any relation whatsoever to nuts?

Candy Math

400 cocoa beans are needed to make 1 pound of CHOCOLATE

Cocoa is a New World Food

+

nougat (noo'gət) from an old French Word noga, nut

=

Introduced in 1932 originally had Vanilla Strawberry and Chocolate nougat

3 Musketeers

3 Musketeers

1844 - Alexandre Dumas publishes "Les Trois Mousquetaires"

+

CARAMEL
mostly
- condensed milk
- Brown sugar
- Butter
- corn syrup

=

Milky Way

1923 - First candy bar introduced by the Mars Family

Milky Way

chocolate manufacturers use 20% of the World's peanuts

+

=

SNICKERS

Introduced in 1930 #1 selling candy bar in the USA

Peanut Butter Cups

I t was a summer Saturday and Chris and I were slow getting out of bed. We had no plans; all we wanted was to wake up together without any notion of how the day would be spent. We craved uninterrupted expanses of each other's company, like any annoyingly self-indulgent couple. I had couples guilt. I had spent so much time as a single girl that I couldn't stand becoming part of a couple who spent all their time in their own little self-congratulatory universe, watching romantic comedies and playing footsy in last year's restaurants. So I made plans for us. We went to parties with our single friends. We socialized in groups. We were always booked, out late, exhausted. Hence the craving for empty space.

After breakfast, the Sunday *Times* seemed like entertainment enough for the whole day, but we gathered it, a Scrabble board, and a blanket and headed out to the park. At a

deli near our destination we stopped for water. Like any good deli, this one had penny candies up by the counter. But it is only the rare deli that stocks miniature white chocolate peanut butter cups. That's right. White chocolate and peanut butter. The first time I found them, I gazed in wonder. These two were meant to be.

I pointed them out to Chris, expecting no interest. He raised his eyebrows and licked his lips. I patted his head. Good boy. We bought a handful.

At Battery Park we spread our blanket under a tree. When we had exhausted the paper, we pinned it down with shoes and turned our attention to Scrabble. I have no argument with Reese's Peanut Butter Cups. They are a topnotch candy. H. B. Reese, a former Hershey employee, set off to make his fortune with peanut butter cups. He really got the "peanut butter" right with his ultra-sweetened, crumbly filling. (So right, in fact, that in the 1960s, twenty years after launching his company, Reese sold it to Hershey for over twenty million dollars.) Somehow Reese, by playing with the formula, removed peanut butter's thirst-inducing density. The cups have a light, perfect balance of chocolate and peanut butter. Natural, homemade peanut butter cups don't compare.

Reese's familiar orange, yellow, and brown branding is so ugly that it's endearing. That packaging is part of Reese's extremely impressive brand extension. Reese's Pieces were stunningly good when they were first released. We finally got to taste the refined version of peanut butter without let-

ting chocolate steal its thunder. It stood alone. Chocolate makes the cups too filling. I can eat Reese's Pieces forever. The candy coating gives the Pieces the delightful crunch of M&M's, but with superlative filling. Their ubiquity has diminished their appeal, but whenever I run into them, I am reminded of their lasting goodness. Especially in movie theaters. Recently the less-than-memorably named Reese's FastBreak hit the market. FastBreak adds chocolate and peanut butter nougat to the mix, with excellent results. The FastBreak is a dangerous path for me. I feel that if I went down it, I might never come back.

But white chocolate takes peanut butter cups in a brilliant direction. They are much sweeter than the milk chocolate sort; one can almost taste grains of sugar in the white coating. I like to eat three in rapid succession, and they are so sweet that I occasionally actually have the feeling that I don't want any more. I don't worry, though; it passes quickly. (As I've said, satisfaction isn't the right word. Candy does not offer satisfaction, only saturation.)

"I can't believe these exist," Chris said. "Who knew?"

I knew. And since they're near cash registers in delis around the city and I've witnessed fluctuating supply in certain of those delis, I know I'm not the only devotee. But it is a stealth candy. I have never, ever seen another person pick one up.

We ate the cups, I won Scrabble, the sun was well behaved. It's too many good things all at once, I told Chris, and he made that into a little song.

Tootsie Rolls

I called my sister-in-law, and my nephew answered the phone. His telephone conversation abilities were blossoming at an astounding rate.

"Who is this, please?" Asher asked.

"It's Hilary," I said. "How are you, Asher?"

"I...I...I had a cookie!" he said, clearly pleased to have come up with big news to communicate.

"That's good," I said. "I had some candy."

"What kind of candy?" Asher asked.

"Tootsie Rolls," I said. There was silence at the other end of the line. Asher was stumped. "Have you ever had a Tootsie Roll?"

"No," he said sadly. "My mother says they're bad for me."

"She's right," I said.

Staleness is the plague of the Tootsie Roll. It most often affects the candy bar–size Tootsie Rolls, which may languish on the shelf longer than the finger-size penny candy or the inch-long nuggets. I was on a Tootsie roll and I had been lucking out. The ones at my corner bodega were always soft and fudgy. This newly reliable freshness matched the ongoing ease of my life, now that Chris was in it. No matter how I feared a sudden change—a souring or staleness—the time we spent together was consistently satisfying.

A fresh Tootsie Roll is always better than one remembers them to be. This has to do with the attempt to flavor them like fudge, instead of straightforward chocolate. But it has mostly to do with their unique, compelling texture. They chew, offering a level of resistance that is both enduring and conquerable. None of that annoying passive-aggressive persistence of flavorless gum. What are you supposed to do when gum flavoring is gone? Keep chewing like a stupid cow? You have to decide when the gum is over. And then you have to choose whether to toss, swallow, or simply add another flavorful stick to your wad. It's too much responsibility. Tootsie Rolls have a natural ending. They chew for a good long time, releasing intense flavor consistently. When they go, it is because they must. They have integrity.

Asher is a sugarhead like me. When he enters a room, he is immediately aware of any candy or desserts that are present in the room. His focus is intense. I look at him and know that my mother is right. This is nature, not nurture.

Name Your Candy

Gobstoppers, Nerds, Laffy Taffy, Pixy Stix: Willy Wonka (owned by Nestlé) has some of the finest candy names. My favorites are the silly, whimsical ones. Why complicate matters? But I also respect some of the older names, from the premarketing days when candy bars were named after the families who invented them. Tootsie (1896) was the nickname of the inventor's five-year-old daughter. Snickers (1930) was named after the Mars family horse. Reese's and M&M's (Mars and Murrie) were both named after the company founders. Junior Mints (1949) was named after the Broadway show *Junior Miss*. The much-contested Baby Ruth (1920) was named after either the company president's granddaughter, Grover Cleveland's daughter, or the Yankee slugger who tried and failed to get royalties for the use of his name.

Then there are the literal names: Tart 'n' Tinies, Almond Joy, Gummy Bears, SweeTarts. Rolo is the best of this lot.

It's slightly descriptive, but isn't silly or straight. It just works. I have grown so accustomed to Hershey's Kisses that I forget they have nothing to do with the shape of an actual kiss. (There is no record of the origins of the name, but Hersheys.com suggests that it may have come from "the sound or motion of the chocolate being deposited during the manufacturing process.")

Whatchamacallit, Krackel, FastBreak, and Kit Kat don't do anything for me. Maybe after years of popularity, Fast-Break will have the same cachet as Good & Plenty. For now, its flip-flop of "breakfast" sounds like a subliminal attempt to promote itself as a new fun food. Too clever. (Although: yum.) If it were mine to name, I'd choose something with more personality. Reese's Folly? Reese's Anytime? I'd need lots of branding meetings and focus groups to get it straight, and yet FastBreak seems like the unfortunate result of too many focus groups.

One day Chris brought a can of Comet back to his apartment with the groceries. He found me looking at it. When I said, "Too bad Mars didn't trademark this name in time. It'd make a good white chocolate bar," he gave me a funny look. (Chris wavers between indulging my love for sugar and helping me control it. All he wants is for me to be happy, but it is no simple trick to balance my desire before and my regret afterward.)

"You'd better be careful," he said. "Lots of those household products sound like candies. Stay away from my Swiffer wipes." He was right. Ajax. Snuggles. It had to be a poison control center nightmare. The next day I came home

to find that Chris had left me a note that said "Clarification Chart" at the top. I think he was concerned that in a moment of desperation I might consume a detergent with a lime-fresh scent. I didn't need the clarification, but it made for a good shopping list.

Is it a delicious candy or a household cleanser?

Product Name	Candy	Household Cleanser
Spree	✓	
Pez	✓	
Wisk		✓
Twix	✓	
Tilex		✓
Pixy Stix	✓	
Drano		✓
Rain-Blo	✓	
Mop & Glo		✓
Spic & Span		✓
Good & Plenty	✓	
Mr. Clean		✓
Mr. Goodbar	✓	
Toilet Duck		✓
Chocolate Bunny	✓	
100 Grand	✓	
10,000 Flushes		✓

Old-Fashioned Marshmallow Eggs: Drawing the Line

When Chris and I moved in together, I made it a rule never to hide sugar consumption from him. It wasn't going to be my dirty little secret. Besides, sugar was losing its status with me. I was happy, in love, and demoting sugar was the next step to a balanced existence. My goal was to see candy as an occasional snack, with no greater meaning and with no guilt. Also, I was tired of going to the gym all the time. My metabolism was over thirty years old, and it wasn't getting any younger. Candy was just candy, I told myself. Minimizing its presence almost felt natural. Most of the time.

But when I discovered that the marshmallow eggs that so elude me were readily available online, I was delighted. I hadn't seen them since Luke stowed them under my pillow,

and that seemed like a lifetime ago. One slight drawback to
the online candy store—the eggs had to be ordered in bulk.
Que sera, sera, I thought, and ordered the five-pound box.
When I tried to check out, however, I discovered that I
hadn't met the website's minimum order. So without blink-
ing I added a five-pound box of Swiss petite fruit to my
order. Minimum satisfied. Customer satisfied.

When I mentioned my success to Chris, he looked a little
shocked.

"You know, ten pounds is really a lot of candy," he said.

"I know," I admitted. "I'm thinking I might get you to
take it to work and then bring me installments."

He looked unconvinced. "But what about before I get
home from work, on the day it arrives? What if you eat it
all?"

"I couldn't possibly eat ten pounds of candy!" I said.

"That may be true," he said, "but I'm afraid you might
try."

"I would probably end up giving a lot of it away," I sug-
gested.

He looked at me skeptically.

"You know," I said, "I think I might try to cancel that
order."

"That sounds like a great idea," he said.

With This Bottle Cap . . .

I got laid off soon after September 11. It was the first time since college that I had been unemployed, and I was glad to be alive, so I took it in stride. Chris and I wanted to take a vacation around New Year's, but with all that had happened, we couldn't bring ourselves to go very far. So we went to Florida, where his parents had a condo. The notion of having hours together by the sea was heavenly.

The only other vacation we had taken together had been to Mexico. We had gone on a twelve-hour bus ride over the Oaxaca mountains during which the bus driver never stopped at a single dusty town to allow us to go to the bathroom. I had a bladder infection the instant I stepped off the bus, and the over-the-counter antibiotics I bought made me nauseated for the rest of the trip. We went to a pizza place

overlooking the beach with hammock-chairs that in any other circumstance would have delighted me. Instead, I was immediately ill. I read thrillers in the shade and watched Chris run in and out of the surf, making sure he didn't go too close to the rocks where, we were told, 100 people a year met their makers.

This time would be different. We would be in Florida, where we controlled our own pit stops. What we had forgotten was that the east coast of Florida is not necessarily hot in December. In fact, as we learned, it can be quite cold. I wore a sweater and jeans on the plane, and every day thereafter. In the dank cold, my hair curled into ringlets close to my head.

"Do you like this purple sweater?" I asked Chris. "You'll be seeing it a lot." The condo had windows looking out on the ocean. We planted ourselves as close to the windows as we could, playing Scrabble, then cribbage. We ate a Carvel ice-cream cake until I told Chris that if I was only allowing myself one sweet thing per day, I didn't want it to be a Carvel ice-cream cake.

On New Year's Eve it was too cold for the short black dress I had brought. No, I would have to wear the jeans again. In a cheap beach shop I found a sparkly black shirt for ten dollars. It was the best I could do. That, my purple sweater, and a pink jean jacket. Sultry. We went to a hotel down the street, where they promised a prime rib dinner, a band, dancing, and champagne toasts. We sat with eight geriatric strangers who managed to represent a cross-section of

retirement clichés. They weren't charmed by, or even much interested in, our youth. We drank but didn't get drunk, danced to the terrible band as they reduced Lionel Ritchie, Jimmy Buffet, the Beatles, and anyone else on the classic rock play list to the same dull whine, and did everything we could to avoid kissing our tablemates at midnight.

"I love you and everything," I told Chris, "but this is still boring. Do you think we should be able to have fun under these conditions?"

"Only a little," he said. "Did you enjoy your prime rib?"

"Oh yes!" It was true. I rarely ate meat, and prime rib always did it for me.

"Well, then," he shrugged. "You've done very well."

The next day, New Year's Day, was as cold and overcast as every day before it. Chris had a cold that he couldn't shake, but he went for a run down the beach anyway. I watched the news in the exercise room.

Later that afternoon we decided to go for a walk. I put the champagne we had brought—some Dom Pérignon that Chris had gotten as a gift—into a bag. I washed some local strawberries.

"Should I bring glasses or paper cups?" I asked Chris.

"Whatever," he said. I packed the glasses. We walked down the beach to a little gazebo Chris had seen on his run.

"Is this good?" he asked.

"Too many people coming and going," I said. It was more private farther down the beach, so we found a drift-

wood tree resting parallel to the shoreline. It was white as the sand and smooth with contour lines. We sat and drank our champagne and ate our strawberries. Because the sky was overcast, there was a silvery gleam to the ocean. We huddled for warmth.

"I've been cold for days now. Days!" I told Chris.

"I know," he said.

I sighed. "This is pretty perfect. Would anything make it better for you?"

"No," he said. "I wouldn't change anything. What about you—would anything make it better for you?"

"Nope," I said.

"Not even . . ." he reached into his pocket. As I saw his knuckles bend into his jeans, it crossed my mind that he might be going for a ring. We had never talked about getting married. When we moved in together, my friends and family started asking about our intentions. I thought we had a future together, but I didn't think that we had to define it in order to try living together. All I knew was that I didn't need anything more, any promise, ring, or guarantee to be happy with Chris. We were already more happy than imaginable. I figured if I started to feel unsatisfied, it would probably mean that I wanted to define our commitment (or that we were done with each other). But I couldn't even picture when that might be so.

"Not even . . . these????" Chris pulled three packs of Bottle Caps out of his pocket. As quickly as the notion of a ring had entered my mind, it flew away.

"Where did you get these?" I demanded to know.

"I have my sources," he said dryly.

"Name your sources!"

"I'm afraid I can't do that," he said.

"I can't believe we've been on vacation for four days and you haven't given those to me. Four days. What were you thinking?"

"Aren't you going to eat them?" he asked.

I thought about it, like the hypnotist lady told me to do. We were drinking fancy champagne and eating fresh strawberries. "Maybe we should wait until later," I told him. "Let's not ruin the champagne with refined sugar."

Chris looked surprised. "I can't believe you're resisting Bottle Caps," he said.

"I'm not. I'm just saving them for later."

"That's right. But you never save for later. I didn't even know you knew those words. What is this 'save'? What is this 'later'? Chris no understand." It was then that I realized that, finally, candy wasn't the center of my attention. I felt no sense of desire or need. I still liked it and wanted to be friends with it, but I wasn't about to call it in tears at two in the morning. It was just itself. Just a dessert.

Eventually Chris prodded me into cracking open the Bottle Caps. There, nestled among root beer, cola, and grape Caps, was an engagement ring. Some people fantasize for years about such moments, but I had never imagined it actually happening. It was a little out-of-body, so I decided to stick with the obvious.

"You got me a ring!" I said, and tried it on.

"I can't believe it fits," he said. We admired it. Then I realized something was missing. I turned to him.

"Excuse me? Is there something you wanted to ask me?"

"Oh yeah," he said.

Meltaways

We got married on a cloudless day the following September. In preparation for our wedding, Chris and I purchased forty-five pounds of candy. I know it sounds like a lot. There were five pounds of jellybeans to be scattered on the tables, and forty pounds of Tootsie Rolls, jellybeans, Kisses, and Skittles to be sorted into little favor bags for the guests. We tied customized toothbrushes to each bundle. Instead of a dentist's name, our names were printed on the brush stems. But I discarded the idea of having candy centerpieces. Flowers are nice too. And I wouldn't want people to think I was obsessed.

On our wedding day I felt calm, happy, and overwhelmingly lucky to be so certain and so loved. Nobody gave me away. Chris and I walked down the aisle side by side and vowed to be grateful every day for each other's love. The rings we exchanged are engraved on the outside with the

words "Now comes the mystery"; we liked acknowledging that the unknown is always oncoming, and that we are committed to each other in spite of and because of that. As planned, candy was on the tables and in the goody bags, and a cupcake tree served as a wedding cake (plated with ice cream, of course). My sugar-nut nephew Asher was in heaven. But my focus was elsewhere — on the festivities, on the friends and relatives from far and near, and on the face of my beloved. Looking back, it occurs to me that in all the toasts, not one person mentioned my sweet tooth. I'm relieved — candy may have been the Elmer's glue of my childhood friendships, but the most credit I'll give it now is as friendship glitter.

Finding my mate hasn't taken away my love for candy. My obsession with sugar may have commenced as a means of finding sweetness in life, but along the way it became a part of my identity. I'll never be a celery-nibbling angel. Not only do I continue to delight in certain favorites, but the idea of a life without candy is gray and incomplete.

Keeping how much candy I consume down to "above average" will probably always be a struggle between taking pleasure and wanting to be healthy. I try making rules — one indulgence per week; only special hard-to-find selections; no candy, only ice cream (because ice cream is closer to being an actual food). So far I don't take my own rule-making seriously, but there's always hope.

I'm also still compelled by the illicit desire, the secrecy and guilt, and the rebellious urge to eat whatever I want, whenever I want, and in whatever quantity I choose. Some-

times I'll get on a candy-eating tear, and have to go cold turkey to bring myself back down to earth.

On one hand, candy is evil. It is bright, pretty, and sweet, but it is a quicksand lover. Once it has you in its grasp, it pulls you deeper and deeper into trouble. On the other hand, candy is a simple joy. It's a fun, tasty snack reminiscent of childhood. For me, candy has been the complex flavor of doubt, fear, guilt, hope, and love. The best I can do is to try to limit it to a bit part in my life—the role of Occasional Indulgence played by rotating cast members.

One last thing: In a candy store in Maine, they sell a candy called Meltaways. As far as I am concerned, Meltaways are nectar of the gods. I could eat them ceaselessly. They are round, flat sugary disks that melt to a paste in your mouth. A candy couldn't come much closer to sugar water if it tried. They come in mint flavors, but are best experienced in lemon, lime, orange, and lavender. I must have them. When I do get my hands on a box, I must eat all of it at once, while Chris tries to sneak one or two before they are gone. A genuine vacation candy, Meltaways are true to their name. They melt gently into nothingness, and with them go all the worries of the world. The three of us make a fine pair.

Candy Memories (from Readers)

OOOOOOOOO

Abba Zabba, Chuckles, and more—here is a taste of the flavorful memories that readers have posted on Hilary's website, www.hilaryliftin.com.

Dorothy Robinson on Red Hots—1990

It was one of my first babysitting gigs as a young girl, and I was so excited. Things were going as smooth as peanut butter Jif until my young client promptly shoved one of those spicy cinnamon hearts up her nose. Stressed, I could see its heart-shaped form on the upper east side of her nostril. She was crying, I was crying (my, it must have burned like the dickens), until I finally got the smart idea to close her left nostril and instructed her to blow, BLOW, BLOW! Whereupon the cinnamon candy heart went shooting out of her, proceeded to be airborne, and hit her younger brother squarely in the eye. Tears of pain and joy emitted from us, and I treated them to a fudge Popsicle as a bribe for not telling their mother. My fifteen-dollar fee was not enough, in my humble opinion, to make up for this psyche-damaging fiasco, and to this day I do not like cinnamon candy hearts or, for that matter, children.

Lisa Root on Abba Zabba—1974

During the long and hazy summers in Southern California,

my friend and I would spend the afternoons under the beady and watchful eyes of my mother, polishing her beloved and ornate teak furniture. It would take hours. In exchange, we would be presented with two shiny quarters each. Off we would go, down dusty Fish Canyon Road until we got to our own private candy mecca: 7-Eleven. The Abba Zabba candy bar would be my find. Thick and chewy, it would actually expand as I pulled at its smooth white stickiness. Occasionally, a glob of peanut butter would find its way up through the sweet, rubbery taffy, and if one were skilled, she could suck the peanut butter right out. Not me. I would savor the sweetness instead, alternately chewing and pulling my way right into the cool of a summer's night.

shauna on Atomic Fireballs—1980
When I was thirteen, my sisters and I spent the summer with my father and his much, much, much younger wife. They had a thing for Atomic Fireballs. Or to be more accurate, he had a thing for the hot and spicy part, she for the sweet. So there we were, my sisters and I, floating around the epically large seat of my father's Cadillac, watching them trade the Fireballs back and forth between big sloppy kisses where tongue was clearly visible. Hot. Sweet. Hot. Sweet. Back and forth. Back and forth. That I am still able to eat Atomic Fireballs is something of a wonder to me.

sirrahc on Blow Pops—1978
When I was seven, I drew a "treasure map" for my older brother of our backyard with a big "X" at the end. I intended to hide a Charms Blow Pop there for him to find. But the

pop looked so good, I decided to eat the candy outside myself, leaving him the gum. So I did that, rewrapped the rest of it, and buried it in the ground. When my brother found the dirt-covered, half-eaten pop at the end of the hunt, he screwed up his face and said, "You can have it." I did.

Catherine Strohecker on gum

One hot evening, after all of the other kids had slurped down our grape Popsicles, I returned to my arduous summer-long task and work site, Popsicle stick–digging/scraping tool in hand. The ground was hot, and my back dripped with beads of sweat from my toil on top of the egg-frying cement. At last, the outside temperature and my own burning tenacity paid off: the darkened, dirt-filled gum finally peeled off in one soft, flattened, conquered piece!

Later that hour, in front of my siblings and neighborhood chums, who were playing kickball in the middle of the toasty-warm street, my mom's hand covered her mouth as if I were some slothlike beast from the lagoon, and she squawked in horror, "Where did you get that gum?!" probably more appalled that I would even think of having something other than raw turnips or radishes in my mouth. With my thumb jabbing behind me like some wayward hitchhiker pointing to the untamed future, I calmly and triumphantly replied, "Over there, next to the home plate on the street."

All she could do was defeatedly reply "Oh, horrors," knowing that whatever bacteria had nestled itself into the gum while baking into the tarred road was now forever coursing happily through and festering within my blood-

stream. She walked back into the house, headed straight down the hallway for the bathroom, and rinsed her own mouth out with Listerine, probably hoping that, through some act of Shirley MacLaine–style channeling, my mouth would be equally sterilized. My siblings looked on in silent, respectful, yet stunned admiration: I had gum and they didn't. Better yet, I didn't get into trouble. Hard work has its merits, even at age five.

Cara mia on candy necklaces—1980
My grandma and Pap used to take us to this tiny roadside candy shop in Zelienople, PA. Armed with my waxed-paper sack and a dollar, I'd systematically fill the bag with four things: Candy Lipsticks, Flying Saucers, Swedish Fish, and Fortune Gum. But the ultimate, ultimate for me, and I could hardly wait to get in the car to start snarfing them down: Candy necklaces. Candy watches. Candy accessories. The old-fashioned kind. I could wear them to church and still nibble them. Years later, a boyfriend packed hundreds of candy necklaces around a jeweler's box containing a pink pearl necklace. He was the first man who got me.

shamrock on Marshmallow Peeps—2003
These must be eaten stale. End of story.

ethel on Necco Wafers—1977
"Body and Blood of our Lord Jesus Christ," I said solemnly, dunking the crisp white powdery Necco Wafer into the wineglass overflowing with Coca-Cola, and feeding it into my two-year-old brother's waiting mouth. Dressed in my

mother's old white graduation gown, I had been careful to separate all the white ones out from the colorful candy roll for the sake of accuracy. I remember going to church and wanting nothing more than to be like the grown-ups who were able to stand in line and "receive bread and wine." So my little brother and I would rush home and make our own Communion—using Necco Wafers and Coca-Cola as a substitute. Two years later, of course, as a second-grader, I was able to receive the sacrament of Communion for real. Pity the Catholic Church never thought to use Necco Wafers and Coca-Cola. It would taste so much sweeter.

Simona on Now and Later—2001

The best candy is Now and Later. Mmmm . . . I ate at least a pack a day all of freshman year during high school. I took all the wrappers and mod-podged my garbage can, and made several picture frames. They are my weakness. I think I should win the prize for eating the most. When I'm not eating them, I am thinking about them.

veloc on Marathon—1977

My family was traveling home from a sporting event held in a distant country town. The road home followed a river, and along this road my family stopped for gasoline. Inside the store, my parents allowed me to choose one candy bar—a very rare treat. One choice stood out—the Marathon candy bar. I had never seen such a large candy bar . . . at eight inches in length, the Marathon was clearly the superior treat. I chose the Marathon, a caramel-and-chocolate candy bar, and greedily ate the entire thing in the backseat of the

car, while my mother drove us home along the riverside road. How delicious it was.

cristel on caramel creams — 1994

My uncle owns a drugstore. Summers when I was little my parents would send me for weeks to stay at my grandparents', and every day without fail, I would ask to go visit my uncle. And every day I went. I used to sit behind the cashier all day, sneaking as many candies as possible from the display. I think that if my uncle ever decided to charge me for all the candy I've taken from his store in the past ten years, thousands would have to be paid. I took everything I could, but it is one candy that will always remind me of those days: caramel creams. I couldn't get enough of them. I would eat one after the other while reading magazines, while my grandfather scolded me because I was spoiling my dinner. I could not have cared less. I would squish them so that half of the cream would come spilling out, and then I'd lick it off before swallowing the whole thing. Caramel creams meant holidays at grandma's to me. They meant being spoiled and being able to do practically anything I wanted, and for a kid that freedom is priceless.

Mercy on Skittles — 2003

This memory is from one hour ago. I have a friend who is probably dying of brain cancer. It is his third tumor in three years. He is far away. I went to Dylan's Candy Bar this morning, where you can buy Skittles in single flavors, the way you can Jelly Belly jellybeans. I bought a big bag of strawberry, which is the only kind of Skittle I like. Around 7

p.m., I phoned my friend in the hospital. I woke him up. He didn't really want to talk to me; he was too sleepy. I said something complicated about how he should call back if he woke back up before 9 p.m. or else blah blah blah, and he couldn't understand what I was saying—couldn't process it because there is some horrible, golf-ball-size mass of tissue pressing on his brain and making it swell. I said goodnight and we hung up. Then I ate the bag of Skittles and searched the web for friends from elementary school. Now it feels like there is a small acid hole in the inside of my cheek from all the faux-strawberry acid.

Ed from Idaho on Jolly Ranchers—1979
Jolly Ranchers, bits, sticks, squares, in any form something special. Green apple has a whiff as pungent as brandy or wine. Watermelon is a faux fruit flavor like few others. I remember a friend in elementary school eating a Jolly Rancher while playing basketball at recess. He called time-out suddenly, stopping the whole game, and staggered off the court. It seems that he'd gotten his teeth (and thus jaws) stuck fast together by biting a Rancher. Some time later, with as much saliva as he could produce, he broke the seal, opened his mouth, and rejoined the game.

Claire Liptrot on frosting—1985
I remember sneaking into my bedroom during my birthday party (every year) to eat the remaining frosting out of the can. My Aunt Carolyn and I would hide until the entire can was finished and then we would sneak back downstairs and endure the knowing looks of my mother and sister.

Beth Ann Dinan-Marin on Chuckles—1985

My candy sweet tooth is most closely linked to my mom. The ritual of splitting a pack of Chuckles with her on the way home from the grocery store or Kmart began around age ten, maybe even earlier. My mom's claim on the licorice piece was firm, but my claim on cherry was unwavering. I remember the casual air we both had about the rest of the package once our favorite flavor was secure! Yellow, green, and orange—their flavors were deemed irrelevant and they would always be eaten first! To this day, if I am shopping with my mom and I see a pack of Chuckles, I plop my change on the counter and the ritual takes place once more!

Elizabeth Rousseau on candy sticks—1979

Do you remember those simple candy sticks that you'd usually find at some ye-olde-general-store or Colonial Williamsburg? They'd be in big glass jars, sorted by flavor, like butterscotch, cherry, horehound, root beer. As far as candy went, they were merely okay; my tastes ran more toward goody Milky Way or Snickers. Their real magic lay in the way you could use them as lip gloss. I'd bite the stick at an angle, give it a few licks, then rub it over my lips to achieve the '70s disco queen look every little girl was after. Thinking of the sweetness of the candy and the thrill of having a shiny, pout-worthy mouth, it's almost shocking what a sensualist one was at age eight. To be honest, though, I can't resist the urge to apply candy lip gloss when I get the chance, even now.

Lydia on Nerds—1986

My cousin S. was always such a glamorous figure to me, es-

pecially in the '80s, when she seemed impossibly cool and grown-up to my little kid self. I can still remember what she was wearing when she introduced me to the candy that's been my favorite ever since: two armfuls of pastel "jelly" bracelets, jeans shorts, and a white T-shirt that had an equally pastel picture of either Boy George or Madonna. She told me to hold out my hands, and poured in a heap of shiny little pink-and-purple nuggets of candy, which just blew my five-year-old mind. Candy was chewy and square shaped, like Bonkers or Starburst or Tangy Taffy—it wasn't supposed to look like psychedelic kitty kibble. To me the candy box itself was as cool as S. was: pink on one side, purple on the other, and covered with cute little big-nosed creatures doing all kinds of '80s things like toting boom boxes or zipping around on four-wheeled roller skates. And the lid, with the little sliding tabs on either side— how neat was that! And of course the candy itself—so crunchy, and just tart enough to make the sweet finish even better. The strawberry/grape box is still my favorite, but the big rainbow box is a close second. My boyfriend makes fun of the scummy green color my tongue turns after eating half of one of those, but it's worth it for the nostalgia.

rory on Williams Sonoma dark chocolate, 10-pound bar—1989

I grew up in a house without sweets. One time when I was about five, there was a mishap at the Centre Super and a box of HoHos was placed in my mother's grocery bags. The box sat on the kitchen counter, unopened, untouched, for a week before my mother went back to the store and returned it (pointing out on her saved receipt that she hadn't paid for it).

She is like that: restraint and honesty. Years later, in a new house, in the thick of the gourmet-ingredients 1980s, she bought bricks of dark chocolate to use when she baked. (Junky, store-bought, high-fructose-corn-syrup sweets were verboten, but she could, on special occasions, turn out an exquisite birthday cake or Sacher torte.) She kept the chocolate on a high shelf, to deter chiseling at it, piece by piece, until it was gone inside an afternoon. When she wanted at it, she had to deploy the step stool or boost herself onto the counter. One afternoon, she forwent the step stool, hopped up on the counter, opened the cabinet, and the bar fell on her head, knocking her out. She was found all woozy and dazed on the kitchen floor, chocolate bar about two feet from her head. While not seriously hurt, she was seriously humiliated.

Brent on Circus Peanuts — 1980

I need to put in a good word for Circus Peanuts. Every time I have them I think of my grandfather. When he retired, he would spend most of his days watching TV and doing crossword puzzles. And if he wasn't smoking his pipe while doing these things, then he was dipping into his big stash of Circus Peanuts in the end-table drawer. As a kid I was very jealous that he got to have a whole drawerful of candy to himself, and I vowed that I would have my own end table full of candy one day.

Alvina on Alexander the Grape — 1988

I used to take the bus home from school with my best friend on some days, and we would always stop at the Little Store (I think that's what we called it!) at the bottom of the hill,

before making our walk up to her house. There, we would buy candy. Our favorites were Lemonheads and Alexander the Grape—both for a dime a box. For those of you not familiar with Alexander the Grape, they were exactly like Lemonheads, except they were grape flavored. Duh. I never found Alexander the Grape again until I was an adult and on some sort of road trip somewhere. I stopped to get gas, and there on the counter were boxes of Grapeheads! (I guess they must have renamed them.) I promptly bought four boxes, and have never seen them again since.

mmz on Old Sol—1966

My fond memories of this chocolate bar are really memories of special, ending-too-soon time with my dad. Dad was stationed at the naval base in New London, but Mom and I stayed in our hometown. He came home every other weekend or so, and on Sundays he would drive to his friend's gas station in Simpson to fill the tank for the trip. I would ride along and would get an Old Sol bar. It was a thin, milk chocolate bar in a cellophane wrapper (clear with red ink, if memory serves). I thought they were wonderful, but what I was really savoring were those last few minutes with my dad until he was gone for a few weeks.

mookleknuck on buttercream frosting—2003

I remember making a first batch of frosting for a friend's birthday cake: white-chocolate truffle with amaretto over an almond dark-chocolate cake. Just typing this makes me remember the light, lush, creamy mouthful on my tongue. It was made with copious amounts of butter and cream and

decorated with milk-chocolate hearts. I can't imagine that my heart won't be paying for it in ten years. (My thighs have never held that diamond, even if I used to be a stick.) Much better than buying store frosting. Much more satisfying. Even though I am a dedicated consumer of homemade whipped cream, I couldn't lick all of the leftover frosting from the above cake.

Dylan on Hershey's Chocolate Bar with Almonds, extra-large size—1971

My grandmother, a radical-lefty-communist rabble-rouser, kept an immense block of Hershey's chocolate in the freezer in her small apartment in Queens. She was all for sharing and sharing alike, but when it came to that freaking chocolate bar, she was more Idi Amin than Trotsky. Though the thing weighed a good seven pounds, I rated only a few slivers each visit. Luckily she slept heavily. I often woke in the middle of the night, heard her snoring, crept to the kitchen, and gorged. She must have known it was me, but she never mentioned it.

Karen Fox on gum—2003

Ever since we met in 1991, my best friend (as well as ex-boyfriend) often offers me a "corner" of his gum—because he knows that I only want the littlest bit. I don't actually like chewing gum, but I like having a hit of the mint flavor. So when he wants to chew a piece, he rips off a tiny part and offers it to me. I chew it for about a minute and then throw it away. We've been doing this routine for over ten years, but he still laughs at me for being so particular every single time. I love him for it.

Semi on dark chocolate — 1974

When I was very small, I was traveling on a train with my parents in Belgium. A nice lady offered me a piece of chocolate. I gobbled it, but it was dark chocolate and I don't know if I was ever so disappointed in my life. She also gave me a lapel pin from Tasmania.

Lanie on Hershey's with Almonds — 1995

I never got to meet my grandmother on my father's side: she passed away long before I was born. But growing up listening to everyone's stories, I learned all about her down to the smallest details: the way she held her hands when she played piano, how she looked on her wedding day (my great-uncle swears she was the most beautiful woman he'd ever seen), and her weakness for Hershey bars with almonds. One year, on what would have been her birthday, I went with my father and one of my cousins to visit her grave — flowers in one hand, chocolate almond bar in the other. We sat by her for a while, laid out the flowers, and listened to my father's stories. Before we left, he unwrapped one end of the chocolate bar and we each broke off a piece. He began to seal it up and then, for whatever reason, he unwrapped it again and turned it over to the side we hadn't looked at — the one stamped HERSHEY. Without the end we'd broken off, the chocolate now read: HERS. So we left it behind for my grandmother — it was her share, after all.

OOOOOOOOO

RESOURCES

OOOOOOOOO

Please stop by www.hilaryliftin.com and share your memories of favorite candies.

ONLINE STORES

Candy Bouquet
www.candybouquet.com
The website for the franchise shows samples of sophisticated candy bouquets.

Candy Crate
www.candycrate.com
Candy bouquets of questionable taste (they come in ceramic planters shaped like Santa's sleigh). But satisfaction is 100% guaranteed. Can't argue with that.

Candy Direct
www.candydirect.com
An almost overwhelmingly large selection including Moofus Pops and huge candy necklaces (24 for $36.50).

Candy Warehouse
www.candywarehouse.com

Possibly the best site—the only one I've found that stocks old-fashioned marshmallow eggs. But the minimum order is $35, which spells trouble.

Groovy Candies
www.groovycandies.com
A personable site with hard-to-find candies from the '50s and '60s. Their sister superstore is www.discountcandy.com.

NostalgicCandy.com
www.nostalgiccandy.com
Great gift boxes by the decade. (Hint, hint.) Random: the Coca-Cola and Scooby-Doo collectibles sections.

Old Time Candy
www.oldtimecandy.com
A family-run business out of Ohio, specializing in the "memory business." You can create your own assortment, but the best part is that their toll-free number is 1–866-WAX-LIPS.

Sweet Nostalgia
www.sweetnostalgia.com
An eclectic site where the nostalgia goes beyond candy into games and family reunions. They even have Wacky Wafers, although they are miniature and made in Canada.

LOCAL STORES MENTIONED IN THE BOOK

Ben and Bill's Chocolate Emporium
Bar Harbor, Maine
www.benandbills.com
Peppermint ice cream year-round, fudge, and the only place
I know that sells Meltaways. It's too much heaven all in one
place.

Door County Confectionery
Ephraim, Wisconsin
Some candy stores you never forget.

Dylan's Candy Bar
New York, NY
www.dylanscandybar.com
With decor inspired by the board game Candyland, Dylan's
is well worth the trip to the Upper East Side. Down the
translucent candy-filled stairs, there are candy nostalgia
showcases. They do parties for kids (and grown-ups, one
assumes), and will put together custom baskets. And if
you're on a diet, they sell candy-scented spa items. My only
NYC Bottle Caps source.

Economy Candy
New York, NY
www.economycandy.com
A Lower East Side neighborhood candy store opened in
1937 with a loyal following. A trip back in time, with real
discounts to match.

The Tuck-Shop
Oxford, Oxfordshire, UK
Haven't been there since 1986. Can't make any promises.

CANDY COMPANIES

Ferrara Pan Candy Company
www.ferrarapan.com
Complete history including photographs, and virtual tours of how their candies (including Atomic Fireballs and Lemonheads) are made.

Goetze Candy
www.goetzecandy.com
Caramel creams and everything else caramel. I like Goetze's history timeline. Don't bother with the explanation of why Cow Tales is spelled as such.

Hershey
www.hershey.com
News, interesting product profiles, and a convenient list of brand websites (www.hersheyskisses.com; www.twizzlers .com; www.reesesfastbreak.com; etc.). The Twizzlers site has some games. I guess I should clarify that I don't play online games, but I appreciate the effort.

Resources

Jelly Belly Candy Company

www.jellybelly.com

A very complete site, even including a shop. A guaranteed source for the bestselling Harry Potter Bertie Botts Every Flavor Beans. I'll take Green Apple, but Dirt? Not so much.

Mars

www.mmmars.com

Oddly, this site doesn't have an index of product home pages so you have to dig around. Some are under the obvious domain names and some are not (www.snickers.com; www.milkywaybar.com). Some samples:

Snickers

www.snickers.com

A spunky site built around the "don't let hunger happen to you" motto.

Skittles

www.skittles.com

A Mars site with a funky desert motif. One of the only sites I found with an active candy fan community.

Starburst

www.starburst.com

A kid-oriented Flash site.

Necco

www.necco.com

Learn their history going back to 1847. Fun facts about Necco Wafers and conversation hearts, and a small but

intriguing store. (If I liked Clark Bars I would want that T-shirt, and the Mary Jane party coasters are adorable.)

Nestlé

www.nestle.com

This site is not highly informative for consumers, but does guide you to a few brand sites, including Wonka. The site www.wonka.com is cute for kids, with Shockwave games. Another Nestlé site, directed at retailers, has more facts about their candies (www.nestlenewbiz.com/products/confections/).

Smarties

www.smarties.com

The Smarties site was written by two fourteen-year-olds, Liz and Emily. It seems to have been their summer job. Some kids have all the luck.

Spangler Candy

www.spanglercandy.com

"Use Spangler Circus Peanuts to make a gelatin treat that everyone will love!" Um, need I say more?

Tootsie Roll Industries

www.tootsie.com

A cheery historical timeline and information about Junior Mints, Tootsie Rolls, Sugar Babies, Dots, and other Tootsie products. If anyone tries the Junior Mint Parfait recipe, I want to hear about it.

FIND OUT MORE ABOUT CANDY

All Candy Expo
www.allcandyexpo.com
The All Candy Expo site often has live links to all the candy companies that are participating in the show, which is most of them.

Candy USA
www.candyusa.org
The National Confectioners' Association's consumer-oriented website. Candy stats and new candy releases are must-visits. Introducing Scorned Woman Chocolate Jalapeño fudge and Soft and Chewy Stinky Feet.

Chocolate and Cocoa.org
www.chocolateandcocoa.org
The consumer website for the Chocolate Manufacturers' Association. Sister site to Candy USA, this one is all about chocolate. Learn how healthful chocolate is for you.

eCandy Marketplace
www.ecandy.com
Official site of the National Confectioners' Association. Everything you don't really need to know about the buying and selling of candy.

The Manufacturing Confectioner

www.gomc.com

Since 1921, the business magazine of the global sweet goods industry. I like the book list here, which contains such gems as *How to Salvage Rework Candy*. There's also a thorough calendar of candy events.

Professional Candy Buyer

www.retailmerchandising.net/candy

The professional magazine for retail and wholesale buyers has critical special reports like "Chocolate Bars Rebound" and "Bubble Gum Report."

Name that Candybar

www.smm.org/sln/tf/c/crosssection/namethatbar.html

Identify the chocolate bar by its cross section. It's much harder than you'd think.

Acknowledgments

OOOOOOOOO

I am grateful to all the folks at Free Press, most especially my brilliant editor Leslie "M&M's" Meredith, her assistant Dorothy "Dots" Robinson, and my sweet-toothed publicists, Sara "stale Swedish Fish" Schneider and Lanie "Life Saver" Shapiro. Lydia "Bull's-Eye" Wills is a dream agent and friend, only sometimes in that order. Patrick "Sugar Babies" Barth risked dental catastrophe to perfect his superb illustrations.

I would like to thank several friends who read the manuscript and gave very wise feedback, much of which was integral to this book: Dylan "Fireballs" Schaffer, Kate "Peanut Butter Cups" Montgomery, Cindy "Skittles" Klein Roche, and Susan "Peppermint Pattie" Choi.

My deepest gratitude is and always will be to Chris "I Prefer Ice Cream" Harris, who helped plenty with the first two parts of the book, but gave me the ending.

About the Author

OOOOOOOOO

Hilary Liftin grew up in Washington, D.C. A 1991 graduate of Yale University, she has worked in the publishing industry for a decade. She is the coauthor of *Dear Exile: The True Story of Two Friends Separated (for a Year) by an Ocean,* a book of letters she exchanged with a friend. She lives with her husband, Chris Harris, in Los Angeles.

CANDY AND ME

Hilary is available to speak to your reading group by speakerphone. For more information, visit www.hilaryliftin.com.

1. Hilary's memories are attached to different kinds of candy. As she writes about Bottle Caps, "When a good thing comes along, memories have a propensity for attaching themselves to it." Did candy play a similar role in your life to its role in Hilary's life? Is there another lens through which you recall events in your life?

2. Candy is both a real and a metaphoric love of Hilary's life. How does her relationship with candy evolve in the course of the book? Do the different eras of her life resonate with your own passage from one life stage to another?

3. What are your favorite candies? What are your family's favorites? Did/does your family have seasonal or ethnic favorites for different holidays, or do you have a single favorite that you have to have daily or weekly? Have these favorites changed over the years? Are your childhood favorites different from what you like now? If so, why do you think that is?

4. Have you ever forged a friendship or bond over candy or some other food, the way Hilary does over cocoa powder and Circus Peanuts? Have you ever forged a bond over a common dislike of a certain food? Have you ever had a disagreement or a fight over the relative value of one candy or food over another? Which is superior, dark chocolate or white chocolate?

5. What are some of the ways that foods help us connect with other people or distinguish ourselves from other people? Do you trust people more who like the candies or foods that you like?

6. What makes a really great candy? What do Junior Mints represent for Hilary? How are they (metaphorically) different from Circus Peanuts? What about the candies that repeat themselves, like Bottle Caps and Marshmallow Eggs? What candy likes and dislikes repeat themselves in your life?

7. Hilary alternately calls candy "evil" and "a simple joy." Which is it? Is Hilary's relationship to it healthy or sick? Is addiction always undesirable, or can it lead to a deeper understanding of life and self?

8. Hilary's parents try different approaches to dealing with her obsession: They forbid candy; they give her an unlimited supply of butter and sugar; her mother tells her she'll be fat. Do you agree with their tactics as she describes them? Does she really seem out of control in her eating?

What would you do if you had a child who wouldn't stop eating candy? How do you put limits on your own indulgence in candy or foods or activities that you love?

9. In *Candy and Me*, the chapters are very short. Hilary doesn't tell how her affair with her camp counselor ends, she says only, "One person moves away, or the other gets bored, or they run out of things to talk about." Is she holding back critical information? Does a complete picture of a life emerge? How is this personal history told differently from other memoirs?

10. Some chapters, like "Trix," are trivial, and some, like "The Assortment" and "Fudge," deal with serious, sad events. Is this jarring to you? Can candy as a metaphor effectively straddle light and heavy issues?

11. Hilary marries Chris, the man who wins her with Bottle Caps. Does Chris feed or quell her candy addiction? Do you have friends or partners who make it easy or hard for you to stay balanced in how you live or what you eat?

12. What critical candies were left out of the book? Does chocolate deserve more attention? Is there a difference between people who eat chocolates and people who eat sugary candies?

13. The chapter "I Know What You're Thinking" says, "What about tooth decay, weight gain, acne, diabetes? I don't want to talk about any of those things." Why does

Hilary address the reader directly here? Were you thinking what she guesses? Did she deal with these issues in the book? Why or why not?

14. At the end of the book, Hilary says of Meltaways, "The three of us make a fine pair." What is she saying about her relationship with candy at this point in her life? Is it resolved? How does a couple best manage different tastes?